Devoted

30 DAYS WITH WOMEN OF THE BIBLE

LIFEWAY WOMEN

Lifeway Press®
Brentwood, Tennessee

Published by Lifeway Press® • © 2023 Lifeway Christian Resources • Brentwood, TN

ISBN: 978-1-0877-7897-6
Item: 005841037
Dewey decimal classification: 220.92
Subject headings: WOMEN IN THE BIBLE

Unless indicated otherwise, all Scripture taken from the Christian Standard Bible®, Copyright © 2020 by Holman Bible Publishers. Used by permission. Christian Standard Bible® and CSB® are federally registered trademarks of Holman Bible Publishers. Scripture quotations marked (ESV) are from the ESV® Bible (The Holy Bible, English Standard Version®), copyright © 2001 by Crossway, a publishing ministry of Good News Publishers. Used by permission. All rights reserved.

To order additional copies of this resource, write to Lifeway Resources Customer Service; 200 Powell Place, Suite 100, Brentwood, TN 37027-7707; order online at www.lifeway.com; fax 615.251.5933; phone toll free 800.458.2772; or email orderentry@lifeway.com.

Printed in the United States of America

Lifeway Women Bible Studies • Lifeway Resources • 200 Powell Place, Suite 100, Brentwood, TN 37027-7707

EDITORIAL TEAM, LIFEWAY WOMEN BIBLE STUDIES

Becky Loyd
Director,
Lifeway Women

Tina Boesch
Manager

Chelsea Waack
Production Leader

Laura Magness
Content Editor

Tessa Morrell
Production Editor

Lauren Ervin
Art Director

Sarah Hobbs
Graphic Designer

Table of Contents

How to Use This Study

Welcome! We're so glad you've picked up this book. *Devoted* is a six-week Bible study on influential women in Scripture. Over the course of the study, you'll learn from the examples of more than thirty women whose lives have inspired generations of people in their faith and devotion to God. Here's a look at what you can expect.

GETTING STARTED

Devoted is divided into six weeks of study; the first three weeks focus on women in the Old Testament, and the last three weeks cover women in the New Testament. The weeks are divided into five days of study, but we encourage you to take it at your own pace. We know some days are busier than others!

PERSONAL STUDY

This is a multi-contributor study, so each day is written by a different woman. As you study, you'll encounter guided reading of Bible passages, commentary to help you understand what you've read, and questions that encourage you to engage with the Bible and apply its truths to your life.

REFLECT

We've set aside time at the end of each week for you to process what God revealed to you during that week of study. Whether you're studying on your own or with others, this gives you the chance to reflect on the character of God and your relationship with Him.

LOOKING FOR MORE?

If you're leading a group or looking for questions to discuss with a friend, don't miss the free leader guide PDF available for download at lifeway.com/devoted. While you're there, check out the group promotional resources!

scan me

A NOTE ABOUT BIBLE TRANSLATIONS AND BOOK ABBREVIATIONS

This study will primarily use the Christian Standard Bible (CSB) and the English Standard Version (ESV) translations of the Bible. Reading the same passage of Scripture from more than one translation is a helpful study tool, and you can find these translations and others on a Bible app or websites such as biblegateway.com or biblehub.com.

The names of the Bible books will be abbreviated when referenced in parentheses in this study. For a complete list of book abbreviations, download the chart available at lifeway.com/devoted.

Introduction

Perfection. From the way our shampoo is advertised to the facade we present on social media, the pursuit of perfection is the hidden heartbeat of femininity. And it's exhausting! The messages we're bombarded with every day have a way of seeping into our souls, complicating our sense of value, and distracting us from worthwhile pursuits.

But hear this: God doesn't care if we are perfect or if we have it all together. In fact, He knows we can't be, and we don't. When pressed on what a "perfect" relationship with God looks like, Jesus had this to say: "If you want to be perfect . . . go, sell your belongings and give to the poor, and you will have treasure in heaven. *Then come, follow me*" (Matt. 19:21, emphasis added).

Despite what you've heard, the perfect life isn't about the way you look, how hard you work, parenting style, number of followers, or number of grandkids. It's about following Jesus—living a life of devotion to Him and extending His love to others (Matt. 22:37-39).

Have you ever noticed the many personal, often muddy details God includes about the women and men who are part of His story? Perhaps He wants to reassure us that like them, we don't have to have it all together either. Perfection is not a prerequisite for receiving God's love or being a part of God's work!

Over the next six weeks, we'll walk through Scripture as we examine the stories of women included in God's Word. None of the women were flawless. Some are remembered for their high points, others are remembered for their lows, and for all of them, we are left with only the briefest of snapshots from their complicated lives. But when you string these pictures together, one thing is clear: *Every one of these women played a role in God's story, a role He deemed worthy of remembering.*

My hope is that their stories will encourage you to look to Jesus, to know with confidence that He loves you, and to live "*wholeheartedly devoted to the LORD our God*" (1 Kings 8:61). Like each of these women, you play an invaluable part in His story, and your life is a picture for others of His kindness and His love.

Laura Magness

Week One

EVE · SARAH · HAGAR
REBEKAH · RACHEL & LEAH

DAY 01

Eve

CREATED BY GOD

by Donna Gaines

Eve's story is found in Genesis 1:26–4:26. She is best known for being the first female, created in God's image to come alongside of Adam as wife and partner; the first mother; and the first to sin by disobeying God's command against eating the fruit of the tree of the knowledge of good and evil. Eve is also mentioned in 2 Corinthians 11:3 and 1 Timothy 2:13-14.

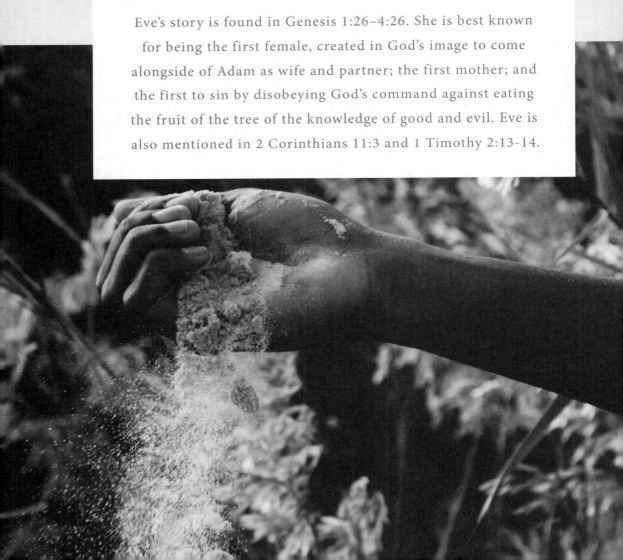

In our current culture, there is much confusion over what it means to be male or female. In fact, most people would have a hard time defining exactly what it means to be a woman. As a woman, the mother of three daughters and grandmother of eight granddaughters, I want to get this right! The one way to clear up the confusion is to go back to God's original design. God clearly communicates His intentions and purpose for creating humanity—both males and females—in Genesis 1–2.

Before we dig into Eve's story, let's lay some groundwork. As you read, I want you to notice how God introduced Himself from the very beginning as the Creator and Sustainer of life. He planned for life to work according to His design and for our flourishing.

TAKE YOUR TIME TO READ THROUGH GENESIS 1–2.

With Genesis 1 readers are given the thirty-thousand-foot view of creation. In rapid succession we read about the beginning of everything from light to darkness, birds of the air to fish of the sea, and everything in between. Genesis 2, on the other hand, zooms in and gives us a few more details. Both chapters reveal very important information about our origin as women.

REREAD GENESIS 1:26-28 AND GENESIS 2:7,18-25.
List everything you learn about the creation of man and woman from these verses of Scripture.

Where did God place Adam, and what one rule did He give him (Gen. 2:8,16-17)?

God created Adam and Eve on day six of creation (Gen. 1:26-31). They were created in God's image and given a blessing and command to be fruitful and multiply and to fill and subdue the earth. They were given dominion over all that God had created. In Genesis 2, we are told God created Adam out of the dust of the ground. He fashioned him into a man and breathed the breath of life into him. Adam became a living soul. Being created in the image of God is what sets men and women apart from animals and the rest of creation.

READ GENESIS 2:18-25 AGAIN. What word is used to describe Eve in verse 18?

In verse 18, God declared that it was not good for man to be alone, and He created a "helper" for Adam. Here, along with Genesis 1:27, we see God's creation of distinct and complementary genders, male and female. Genesis 2:18 is easily misunderstood to imply women are inferior to men, but nothing could be further from the truth. The word translated "helper" is *ezer* in the Hebrew. Consider this understanding of the term:

> Thinking regarding the **ezer** began to change when scholars pointed out that the word **ezer** is used most often (sixteen out of twenty-one occurrences) in the Old Testament to refer to God as Israel's helper in times of trouble . . . The **ezer** is a warrior, and this has far-reaching implications for women, not only in marriage, but in every relationship, season, and walk of life.[1]

Eve, just like Adam, was an image-bearer of God. God knew the work He had given Adam would be impossible to do alone; he needed Eve. They were made to complement one another. And not until after Eve was made did God declare His creation "very good indeed" (Gen. 1:31). Created in the image of God as an *ezer* (helper), we are essential to God's plan. We support the work He is doing in our churches, homes, local communities, and around the globe.

When you read about God's creation of Eve, what stands out to you? How do these verses compare with the messages you're hearing about gender and identity in culture today?

Many things may have crossed your mind as you reflected on Eve's creation, but I want to draw your attention to two. First is the communal nature of God. The creation of Eve as a helper or companion for Adam reminds us of the Trinity—the relationship between the Father, the Son, and the Holy Spirit. Community and relationships are a part of God's very being, and they have been in our nature from the beginning, too. We are not meant to do life in isolation. Second, Paul in Ephesians 5 teaches us that Genesis 2:24 is actually about Christ and His church. Not only does the relationship between Adam and Eve model God's relationship with Himself, it models the relationship He desires to have with you and me.

NOW READ GENESIS 3:1-19. Look closely at Genesis 3:4-5. Summarize the serpent's deception. How did he entice Eve? Why do you think Eve succumbed to the temptation?

The enemy's tactics have not changed. Just as he tempted Eve to doubt and deny the word of God, he also whispers doubts into our ears. Essentially, he told Eve that God was not good, that He was holding out on her. If she would break God's one rule, she could be like God. We have been trying to be God ever since. What did Adam and Eve gain by disobeying God's one rule? Separation from God—an unimaginable consequence—which led to things like fear, guilt, shame, separation in their relationship with each other, and ultimately, death. The Bible is clear that the wages of sin is death (Rom. 6:23). Adam and Eve's sin did not just affect them. Their sin was passed to their children. In Genesis 4, Eve's role as the first mother is overshadowed by the wages of sin as her son Cain killed his brother Abel. And this is the pattern that continues even today.

REREAD GENESIS 3:15, AND READ 3:20-24. What do God's actions following the first sin teach you about Him?

God killed an animal that He had declared good to cover Adam and Eve. Here we see the mercy of God as well as His provision. This animal foreshadowed Jesus Christ, the Lamb of God slain for the sins of the world. Christ's blood covers us from our sin, and we are now clothed in His righteousness. Jesus was also in view in God's curse of the serpent (Gen. 3:15). He will destroy Satan, the serpent, once and for all (Rev. 20). Because God is good and only does good, we can give Him thanks. God has provided "the way" (John 14:6) for us to be in right relationship with Him. Cling to Jesus. Allow Him to redeem your story. Let's learn from Eve. As you'll see in the days to come, the story of every woman in the Bible—and your story and my story—is influenced by Eve.

End your study today with a time of reflection and prayer. How does Eve's story impact your own relationship with and devotion to God?

DAY 02

Sarah

CHOSEN BY GOD

by Mary C. Wiley

Sarah's story is found in Genesis 11–25. She is best known for being married to Abraham, being mother to Isaac and the nation of Israel through him, and laughing at God when He promised she would bear children in old age. Sarah is also mentioned in Isaiah 51:2; Romans 4:19; Romans 9:9; Galatians 4; Hebrews 11:11; and 1 Peter 3:6.

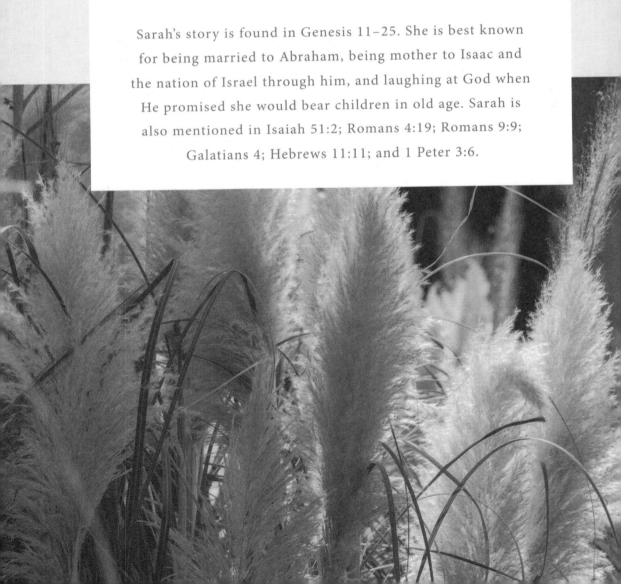

While Gen Z and Millennials likely feel this pressure most acutely, it's no secret that social media algorithms encourage us to carefully cultivate personal "brands." The algorithm loves a perfect aesthetic and singular focus. But behind every beautiful set of photos is a real person with real emotions, dreams, fears, faithfulness, and doubt. People are far more complicated than a screen communicates.

Similarly, as we read the story of Abram and Sarai (later renamed Abraham and Sarah), there are thousands of days we don't get to see lived. It's easy to forget Sarah was a real person living in a particular time. I'll be the first to admit I'm not always a huge fan of hers, but God highlights her faith for us (Heb. 11:11). She's complicated with faithfulness and failings, as are you and me.

READ GENESIS 12:1-5 AND GENESIS 15:1-6.

The book of Genesis records the stories of the patriarchs of Israel—Abraham, Isaac, and Jacob. They were God's chosen family through whom the nation of Israel, and eventually the Messiah, would come. This Messiah was the Savior God promised in Genesis 3:15, the One who would fix what broke when Eve sinned. Abram was the first patriarch, and Sarai was his wife.

Look up the word *bless* in a dictionary and then come up with your own definition.

God promised to make Abram into "a great nation," to "make [his] name great," and to bless others through him. This blessing stands in direct opposition to the curse, given in Genesis 3. After sin separated people from God, here we see that the Promise-Maker is establishing Himself as the One who will do all the work of drawing them back to Himself; and He planned to use Abram and Sarai in that process.

We don't know what the conversation was like between Abram and Sarai after God called them to uproot their lives, but we know they obeyed, setting out toward Canaan with all their possessions, likely without intentions to return. And when God later repeated these promises and provided Abram with more details, he "believed the LORD" (Gen. 15:6). God made Himself known, and obedience was Abram and Sarai's response.

Think about a time when God clearly intervened in your life. Did you respond with obedience and faith, or did you choose not to listen?

READ GENESIS 16:1-6.

Sarai was barren, which often brought deep shame on people who lived in an agrarian society that highly valued having heirs who could join in the difficult job of working the land. Considering her old age, Sarai devised a plan to secure the offspring God had promised Abram. It would not have been unusual for children to be born in this way, through a surrogate of sorts. Yet, it is framed as unwise here because the motive was to take the fulfillment of God's promise into their own hands.

Who did Sarai say had kept her from having children?

How many years had passed since God initially promised to bless Abram's offspring (Gen. 12; 15)?

We can imagine Sarai's frustration. It's been quite some time since this promise was made, and she's well beyond child-bearing years; even if she was able to have children it would have been seemingly impossible at her age. For her to have children now would only be possible if God worked a miracle.

What do you learn about Sarai here? About her relationship with God? Note any similarities you see between Sarai and Eve.

We'll look more closely at the ramifications of Sarai's plan tomorrow when we study Hagar. But for now, let's focus on Sarai. Like Eve, Sarai failed to trust God and instead took matters into her own hands. Also like Eve, she was quick to blame her husband for the consequences of her own mistakes.[2] The patterns of sin in the early chapters of Genesis are the same patterns we see in our own lives today, aren't they? When Sarai's plan succeeded, chaos ensued. Sarai's treatment of Hagar brought about contempt, and Hagar's contempt for Sarai brought about regret. Sarai blamed Abram, everything spiraled, and eventually Hagar fled.

READ GENESIS 17:1-22; GENESIS 18:10-15; AND GENESIS 21:1-7.

To Abram and Sarai, the delay in fulfillment of God's promise led to doubt and impatience, but God had not forgotten. God reestablished His covenant with Abram, giving him and Sarai new names—Abraham and Sarah—and ultimately new identities as the parents of a chosen nation (Gen. 17). Then one day, Sarah and Abraham received God's promise (Gen. 21), but it was bigger than they could have imagined. Eventually, God would bless all the world in Christ, the offspring (Gen. 3:15) who would come from their lineage (Matt. 1). God's faithfulness never falters.

READ GALATIANS 4:21-31 AND HEBREWS 11:11-19. How does Sarah's story fit into the bigger story of Scripture, the story of God's redemptive work to draw us back to Him?

Galatians 4:21-31 reveals Sarah as an illustration of the new covenant, or the new relationship between God and His people, in Christ. We are her children, miraculously born out of barrenness into freedom. All of this is through the work of God alone. He is the Enactor of the covenant, the Provider of the means, and the Giver of freedom. Hebrews 11 paints Sarah as having lived in faith, despite her missteps and sins. All would be blessed through her because Jesus would be born from her lineage. God would faithfully keep His promise in both giving Isaac and sending Jesus. His call was simply trust and patience. The call for trust and patience is also our call today.

End your study today with a time of reflection and prayer. How is your faith challenged by Sarah's example and the examples of God's faithfulness you see in her story?

Hagar

SEEN BY GOD

by Elizabeth Hyndman

Hagar's story is found in Genesis 16 and Genesis 21. She is best known for being Sarai's servant and the mother of Ishmael. Hagar is also mentioned in Genesis 25:12 and Galatians 4.

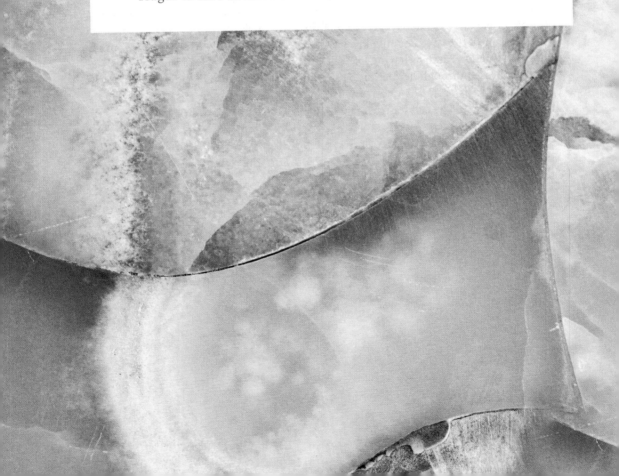

In Genesis 2, we read about man's first assignment: naming the animals. I would love more details here. I want to know things like how Adam chose names and what the language was like then. I can get lost in these questions for quite a while, but my point here is that from the beginning, naming has been important; it's worthy of three verses (Gen. 2:19-20; 3:20) in the brief creation narrative. In today's study, we'll look at a woman who gave God a name. And *her name* was Hagar.

> READ GENESIS 16:1-6. These are verses you looked at yesterday from Sarai's perspective. Today let's consider Hagar. Who was she? List everything you know about her from these verses.

We don't know for sure, but many scholars believe Hagar was probably acquired as a servant for Sarai during her time in Egypt. The word translated *slave* or *servant* in Genesis 16:1 indicates that Hagar was most likely a personal servant of Sarai's, not a common household slave. This gave Sarai the authority to command her.[3] While the practice of having a slave become a surrogate wasn't completely out of the ordinary at the time, Scripture makes it clear that Sarai's offering of Hagar to Abram was wrong. In Genesis 15, God promised Abram that his descendants would be more numerous than the stars. Genesis 15:6 says that Abram believed God. However, in the very next chapter, he trusted Sarai's impatience over God's timing. Abram slept with Hagar, and she became pregnant.

> You considered this briefly yesterday, but look more closely at Genesis 16:4-6. What happened to the relationship between Sarai and Hagar once Hagar knew she was carrying Abram's child? How was Hagar personally affected by Sarai's decisions?

Hagar looked upon Sarai with contempt (v. 4). We don't know what that looked like and can only imagine the specifics, but we do know that Sarai blamed Abram for Hagar's contempt of her (v. 5). Abram told Sarai to do what she wanted with her servant; this was a reversal of roles for Hagar—from Abram's "wife" (16:3) and the mother of his child back to the servant of his wife. Sarai mistreated Hagar, so Hagar ran away (v. 6).

READ GENESIS 16:7-16. Make a list of all the actions attributed to the angel of the LORD/the LORD in these verses.

After Hagar left Sarai's, we're told "the angel of the LORD found her by a spring in the wilderness" (v. 7). We don't know who the angel of the LORD is in this passage. *Angel* literally means *messenger*, so it could be that this is a messenger of God. Some scholars believe that the angel of the LORD in this passage is the preincarnate Christ, meaning the Son of God before He took on flesh and dwelt among us. The way the angel of the LORD was spoken to and spoken of in this passage does seem to support the belief that "the angel of the LORD" in this case is divine.[4] The angel of the LORD found Hagar. He spoke to her. He heard her. God is almighty, sovereign, all-knowing, and all-powerful. He is also personal. He came to a young slave woman on the run and spoke to her. Let that sink in for a second.

> What promises did the angel of the LORD make to Hagar?
> Why would those promises be important for her, based on what you know about her life?

Hagar came from a world where the gods "did not reveal their natures."[5] They were far-off; the God of Abraham came close. Not only that, but He gave a promise to Hagar. He told her to name her son Ishmael, which means "God hears." He said her son would be like "a wild donkey" and would "settle near all his relatives." The *ESV Study Bible* points out that this shows Ishmael's life would be unlike his mother's—enslaved in a foreign land. Instead, he would be independent but live a life in hostility toward others.[6]

> **REREAD GENESIS 16:13.** What name did Hagar give to God, and what did it mean?

What does Hagar's story tell you about God? What emotions does her story stir up in your heart?

In verse 15, we learn another important aspect of Hagar's story. She had a son, and Abram named him Ishmael. Fast forward in Hagar's story. Sarah and Abraham have new names and a new son, Isaac.

NOW READ GENESIS 21:8-21.

Once again, we find Hagar hopeless and in the wilderness. This time, Ishmael is with her, and it doesn't look like they'll survive. In verse 17, we read that "God heard the boy crying."

COMPARE GENESIS 21:8-21 WITH GENESIS 16:7-16. How does the passage in Genesis 21 call back to and fulfill the passage in Genesis 16?

In both cases, Hagar found herself in the wilderness due to wrong behavior toward Sarah. The first time, she treated Sarah with contempt; the second time Ishmael mocked Sarah's son. In each scene, God approached Hagar. He saw her and heard her. Hagar's name means "flight." It's possible it has roots in the word for "stranger" or "foreigner" as well.[7] Hagar was a slave, a stranger, a flee-er, and God saw her. You and I were also slaves, trapped in our slavery to sin, and God saw us. And He has set us free through Jesus, the ultimate fulfillment of God's promise to Abraham.

How are you comforted today by the truth that God sees, knows, and loves you?

Spend a moment in prayer. Thank God for including Hagar's story in Scripture. Praise Him for being the God who sees us and the God who hears us in our distress. Confess any wrong behaviors, knowing that our heavenly Father is a personal and loving God who sees you.

DAY 04

Rebekah

USED BY GOD

by Rachel Matheis Shaver

Rebekah's story is found in Genesis 24–28. She is best known for being married to Isaac, Abraham's son; mother to twins Jacob and Esau; and favoring her son Jacob and manipulating situations to gain him favor. Rebekah is also mentioned in Genesis 28:5; 29:12; 35:8; 49:31; and Romans 9:10.

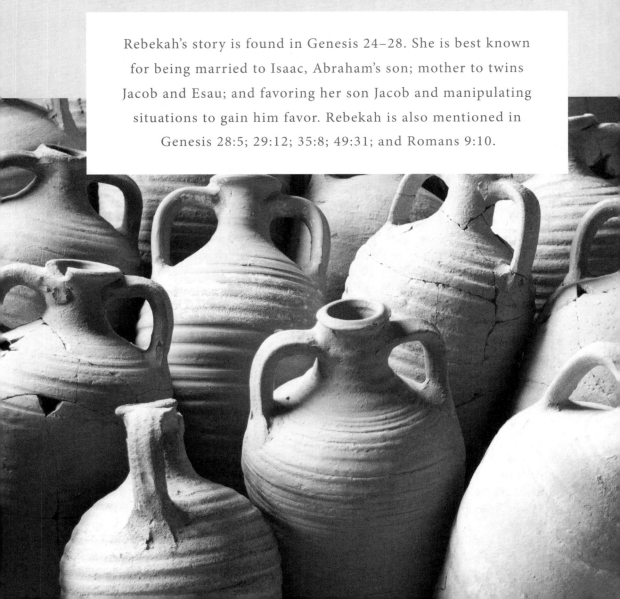

Let me start by saying that we are going to cover *a whole lot of ground* in Genesis as we look at Rebekah's story today. Stick with me! I'll point out the parts that will help you connect the dots and do my best to summarize chapters so you'll finish today's study learning a lot about the role Rebekah played in God's redemptive plan for His people through Jesus.

> **LET'S BEGIN BY READING ALL OF GENESIS 22.** Then reread verses 17-18. What did God promise Abraham? Write His promise to Abraham below. We will come back to this again and again.

Rebekah's story begins here in Genesis 22:23, chapters before we learn about her. Bethuel is the father of Rebekah, and Bethuel is also the nephew of Abraham.

> **NOW READ ALL OF GENESIS 24.** Write down any observations you have about how you see God at work in this part of Rebekah's story.

Sometime after Sarah died, Abraham set out to find a wife for their son, Isaac. He wanted Isaac's wife to not be from Canaan but from his homeland and more specifically, from his family. So, Abraham gave his servant very specific instructions and sent him on his way. The servant knew this was a monumental task. He prayed to God a very specific prayer for help finding the right wife for Isaac. He wanted to be certain he was acting within the will of God. And over and over again in Genesis 24 we see confirmation that he was.

God knew Abraham's commitment to their covenant, He knew the servant's heart to honor his master, and He knew exactly where Rebekah should be at exactly the right time, "before [the servant] had finished speaking" (v. 15). God heard the servant's specific prayer and gave a specific answer. God didn't leave any room for confusion. He saw the exact need and provided perfectly.

When was the last time God answered a specific prayer of yours? How did you respond?

What a great God we serve. When we pray, God hears us. When we have a need, God is able to provide. When He provides, our response should be worship in the form of gratitude, like the servant did (Gen. 24:26-27). It's easy for us to feel like God doesn't care about the details of our individual lives in this grand narrative of His, but there isn't anything further from the truth. He sees. He hears. He is in the details. And He provides perfectly.

REREAD GENESIS 24:60 AND GENESIS 22:17-18.
What do you notice?

They're almost exactly the same. There's no indication that Rebekah's family knew of the covenant God made with Abraham, yet here God was providing a reminder to this budding family and to us thousands of years later that He knew exactly what He was doing, perfectly.

Since we can't dive too deep into Rebekah's story in the limited time we have today, use this chart to examine some of her key moments. (If or when you have the time, read through all of Genesis 24–28.)

Bible Passage	Observations about Rebekah, her relationship with her family, and/or her role in God's bigger story
Genesis 25:19-26	
Genesis 27:1-40	

Bible Passage	Observations about Rebekah, her relationship with her family, and/or her role in God's bigger story
Genesis 27:41–28:9	
Genesis 49:28-32	

Like many of the women in Scripture, some of Rebekah's high points and some of her low points have been preserved for us. Rebekah struggled to become pregnant, similarly to her mother-in-law, Sarah. Isaac went to the Lord on her behalf, and God was receptive to his prayer. Rebekah became pregnant with twins, Esau and Jacob. Chapter 26 has Isaac and Rebekah moving because of a famine, and chapter 27 has Rebekah and Jacob stealing a blessing meant for Esau from an old and blind Isaac (most definitely not her finest moment). Because of this, Esau conspired to kill his brother, and chapter 28 opens with Isaac and Rebekah sending Jacob away, back to the land of his mother. Sin wreaks havoc on family relationships, but God is faithful to His promises.

FLIP OVER TO MATTHEW 1:1-17, which chronicles the genealogy of Jesus, and read it now. Rebekah isn't mentioned in the genealogy, but which verse is she part of?

Rebekah was the grandmother of the twelve tribes of Israel ("Judah and his brothers," Matt. 1:2). More importantly, Jesus—the Savior of the world—was born to a descendant of Rebekah and Isaac. Remember the promise that God made to Abraham back at the beginning of our study today?

I will indeed bless you and make your offspring as numerous as the stars of the sky and the sand on the seashore. Your offspring will possess the city gates of their enemies. And all the nations of the earth will be blessed by your offspring because you have obeyed my command.

GENESIS 22:17-18

We've read about Abraham and Sarah, Isaac and Rebekah, and their many descendants. But as numerous as the stars of the sky and sand? That's a tall promise. But God . . .

> And if you belong to Christ, you are Abraham's seed, heirs according to the promise.
>
> *GALATIANS 3:29*

Did you catch that? If you call Christ your Savior, then God's promise to Abraham is a promise that He made to all of us; for because of Jesus, we are all heirs of a new promise that He ushered in with His death and resurrection. Remember the blessing Rebekah's family gave her as she went away to be Isaac's wife that sounded strangely like the covenant God made with Abraham?

> After this I looked, and there was a vast multitude from every nation, tribe, people, and language which no one could number, standing before the throne and before the Lamb. They were clothed in white robes with palm branches in their hands. And they cried out in a loud voice: Salvation belongs to our God, who is seated on the throne, and to the Lamb!
>
> *REVELATION 7:9-10*

The family that God promised to Abraham? It's all of us who have been sealed by a promise, secured by the death of God's Son, Jesus. Because of God's infinite mercy and grace, we claim an eternal inheritance. God's plan all along was for Rebekah to help usher in generations that fulfill God's promise made to her father-in-law. The amount of detail and care that God has woven into this grand narrative tells us so much about who He is—our compassionate, promise-keeping God. Every single detail of our lives? What has been and what will be? He knows, sees, and cares.

What is weighing your heart down? Give it to God, and trust Him to work it out for you. Thank Him for being in every detail of your every day.

God sees.

God hears.

God is in

the

details.

DAY 05

Rachel & Leah

REMEMBERED BY GOD

by Amanda Mejias

Rachel's story is found in Genesis 29–35. She is best known for being sister to Leah, married to Jacob, mother to Joseph and Benjamin, and one of the mothers of the tribes of Israel. Rachel is also mentioned in Genesis 46:19-25; Genesis 48:7; Ruth 4:11; Jeremiah 31:15; and Matthew 2:18.

Leah's story is found in Genesis 29–35. She is best known for being sister to Rachel, married to Jacob through her father's deception, and mother to six of the tribes of Israel, including the tribe of Judah which would be the line of Jesus. Leah is also mentioned in Genesis 46:15-18; Genesis 49:31; and Ruth 4:11.

If you told me four years ago where I'd be today, I wouldn't believe you. At that time, I was six months pregnant and terrified of becoming a new mom, and I was working a ministry job that completely drained me spiritually and emotionally. My husband worked alongside me, and I wondered daily if he would ever be happy again. Even though we were surrounded by so many loving friends, it was a dark and lonely season for me. I felt like God had forgotten me. I remembered praying often and telling Him things like, *Was going to seminary just a waste of my time? I don't want to be a mom yet; I'm not ready. Why did You put this passion in my heart if You're never going to let me do anything with it? GOD, WHAT ARE YOU DOING?!*

Have you ever had a time in life when you felt similarly? Reflect on it and note what you remember your attitude toward God being like.

In Genesis 29 and 30, we meet Rachel and Leah—two sisters in unique and undesirable situations. They were both the wives of Jacob, yet one longed for the affection of her husband while the other desperately wanted to bear children. And even though they were each richly blessed in unique areas, they could not focus on anything but what they didn't have and how God had seemingly forgotten to come through for them.

READ GENESIS 29:13-35 AND 30:1-16. What was the desire of Leah's heart? What did Rachel long for?

How did each sister try to take matters into her own hands?

I relate to Rachel and Leah more than I'd like to admit. I sympathize with their longings and discontentment, because I know what it's like to have unanswered prayers and unmet desires. We're still in the first book of the Bible, and already patterns of behavior are developing that we recognize in our own lives and relationships. I know how difficult it is to trust in God's goodness and sovereignty when life doesn't make sense or is just plain miserable. I often try to become my own

god and manipulate the best solution or outcome as if I have the power to control my life or circumstances.

We are so easily convinced that we know better than God what we need and what is best for our lives. Leah and Rachel sure thought they knew what they needed. And honestly, who could blame a wife for wanting her husband's love or a woman for wanting to have children? Those things seem like wonderful and godly desires to have! Why on earth would God want to withhold such good things? Wait. But does He *really* withhold good things?

READ THE FOLLOWING PASSAGES, and write down what each Scripture says.

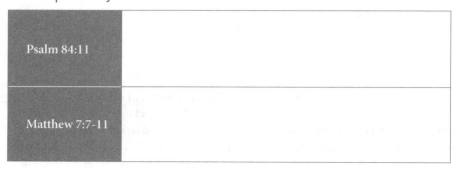

Psalm 84:11	
Matthew 7:7-11	

OK, so if God doesn't withhold good things from His children, what was He doing with Rachel and Leah? While we know that both sisters had unanswered desires, we can see in Scripture that God involved them in His good plan.

READ MATTHEW 1:1-17. Like Rebekah, Rachel and Leah are not named in Jesus's genealogy, but they are there. Which verse gives a nod to their roles in God's salvation story?

Rachel and Leah would never know the full story God was writing for them and their children. They would never know how God would write their names and stories into Scripture. They would have no idea their sons would become heads of some of the leading tribes of Israel (Gen. 49:1-28) They wouldn't believe that one of Rachel's sons would be Jacob's personal favorite and become ruler over Egypt (Gen. 41). And they would never expect that Judah, the son of the less beautiful and less loved Leah, would one day be the family line into which the Savior of the world would be born (Matt. 1:2).

The danger for us is to assume that if we wait long enough, God will eventually give us what we think He's withholding from us. I imagine all of us have learned the hard way that simply isn't the case. Whether God gives us what we're asking for or not, the point is that He is the One we ask. He is the One to whom we lament. And He is the One we trust to know what we really need in order to play our part in His story.

I'm reminded time and again of how Isaiah 55:8-9 says,

> "For my thoughts are not your thoughts, and your ways are not my ways." This is the LORD's declaration. "For as heaven is higher than earth, so my ways are higher than your ways, and my thoughts than your thoughts."

God's ways are simply so much better than ours. His way is far greater than what I could have come up with for my own life, and it's better than any plan that Rachel and Leah could have forced or manipulated.

If you find yourself longing for God to come through, how does this truth impact the way you view God and wait on Him in this season?

Spend a few minutes in prayer. Confess any ways you have forgotten to trust God's goodness and sovereignty over your life or any areas where you're struggling with things like contentment, joy, or gratitude.

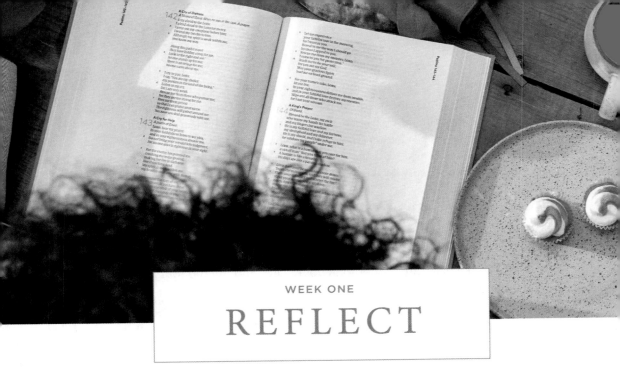

REFLECT

Eve, Sarah, Hagar, Rebekah, Rachel & Leah

Take a few minutes to reflect on the truths you uncovered in your study of God's Word this week.
Journal any final thoughts below, or use the space to take notes during your Bible study group conversation.
The three questions on the opposite page can be used for your personal reflection or group discussion.

Download the *Devoted* leader guide at lifeway.com/devoted

As you reflect on the Bible passages you read this week,
what stands out to you about the character of God?

How have you been challenged and encouraged in your relationship
with Jesus through the Scripture you studied?

Write down one way you can use what you've
learned this week to encourage someone else.

Week Two

TAMAR • MIRIAM • RAHAB
DEBORAH • NAOMI & RUTH

WEEK TWO

Tamar

REMINDER OF GOD'S FAITHFULNESS

by Emily Dean

Tamar's story is found in Genesis 38. She is known for being Judah's daughter-in-law and mother to two of his children. Tamar is also mentioned in Ruth 4:12; 1 Chronicles 2:4; and Matthew 1:3.

I know that you can do anything and no plan of yours can
be thwarted.

JOB 42:2

Have you ever encountered a difficult situation and wondered how God could possibly bring good from it? From our vantage point, sometimes our circumstances can appear hopeless. Our human perspective is limited, but God's perspective is unlimited. In today's study, we're going to look at how God ultimately brought about His gracious plan through a tragic situation.

READ GENESIS 38:1-11.

The account of Judah and Tamar is couched in the Joseph narrative in Genesis between Joseph being sold into slavery (Gen. 37) and then thrown into prison (Gen. 39). The inclusion of Judah's story at this place in Genesis contrasts Judah's poor choices against God's gracious choice of Judah being the tribe from which Jesus would descend. After capitalizing on his brother Joseph's misfortune (Gen. 37:26-28), Judah left his family and married outside of the Israelite clan. Things began looking up for Judah as God blessed him with three sons, until his sons began making their own poor choices. And here we see Tamar enter the picture, the woman whom Judah chose to be the wife of his oldest son, Er. Let's see what we can find out about Tamar from the text.

What does Genesis 38:6-11 tell us about Tamar? List each event of her life in order.

After her husband died, Tamar experienced a custom that would later be known as levirate marriage. (Read Deut. 25:5-10 for more background here.) Levirate marriage "is the marriage of a widow to her husband's brother."[1] It was a practice that helped to ensure both provision and care for the widow and an heir for the family line. Prior to the established law, custom dictated that only the father-in-law could release his daughter-in-law from family obligations and allow her to marry outside the family. So, Judah had control of Tamar's future.

Judah failed to see that his sons' deaths were the result of their actions. Instead, he blamed Tamar and made the excuse that his youngest son was not old enough to marry. Rather than allowing Tamar to live in his home and continue to care for her as was his responsibility, he sent her back to her own home.

Where do you see God at work in these verses?

God is directly involved in executing judgment on Judah's oldest two sons, a sign for readers that Judah's line faltered at this point in the narrative. Perhaps influenced by Judah's Canaanite wife or his own selfishness, Judah's oldest children turned from the God of his father Jacob. In the midst of God's judgment, we also see God's mercy as Tamar was able to return to her father's house rather than being left destitute.

NOW READ THE REST OF TAMAR'S STORY IN GENESIS 38:12-30. In your own words, summarize what happened in these verses.

As you compare Tamar's actions to Judah's actions in this story, what stands out to you? What surprises you?

To our eyes, Tamar's actions may seem shocking. Knowing that Judah failed to fulfill his promise, she took matters into her own hands to secure her future. Tamar failed to trust God's provision for her, but in spite of that, we see God working through her. In fact, she is repeatedly mentioned as an important part of Israel's history (check out Ruth 4:12), and Judah even goes so far as to call her "righteous" (v. 26, ESV). Judah needed a legitimate heir to fulfill God's promise to Eve (and then Abraham), yet he and his sons put that promise in jeopardy. Through God's faithfulness, the seed of His promise is preserved.

READ MATTHEW 1:1-17. (Focus specifically on verse 3.)
What does Tamar's inclusion in the lineage of Jesus tell you
about God? About His work in her life?

Though Tamar's story catches us off guard, one thing shouldn't—God's faithfulness to His promise. God in His infinite mercy is always faithful to His plan. Tamar's children, Perez and Zerah, are both key figures in the line of Judah. Scripture does not tell us what became of Tamar and whether she lived in Judah's household and raised her children in the awe and instruction of the Lord. We do know that her sons, unlike Judah's oldest two children (whose lives were cut short in acts of judgment from the Lord) were regarded as blessed by the Lord. Tamar was even one of the few women mentioned in the lineage of Jesus. Though sometimes mentioned directly and at other times indirectly working behind the scenes, God was acting redemptively on behalf of this family in and through it all.

How can you actively choose to trust God to bring good in your circumstances right now?

Write a prayer of thanks for God's grace in your life. Express gratitude that He fulfills His promises even when people do not. Ask the Lord to help you trust Him to bring about His good purposes for your life.

DAY 02

Miriam

PICTURE OF GOD'S GRACE

by Yana Jenay Conner

Miriam's story is found in Exodus 2; 15; and Numbers 12.
She is best known for being Moses's sister, helping with
his rescue from the Nile, questioning his leadership in
the wilderness, and being a prophetess of Israel. Miriam
is also mentioned in Numbers 20:1; Numbers 26:59;
Deuteronomy 24:9; 1 Chronicles 6:3; and Micah 6:4.

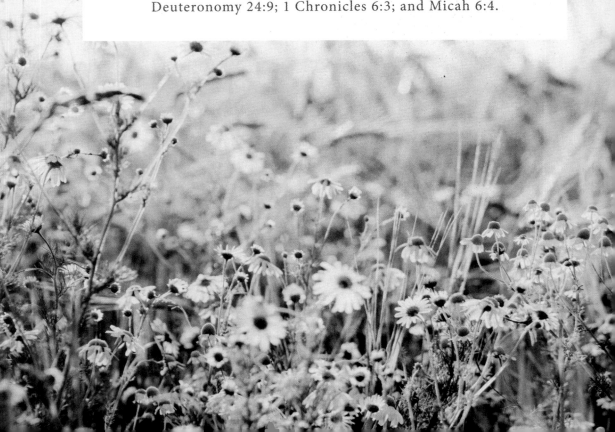

Every person's story is filled with highs and lows. In the pages of the books of our lives, you can find a record of both our shining and most devastating moments. The good and the bad, taking turns, like flipped pages, exposing the best and worst of us all. Today's reading will invite us to reflect on the highs and lows of the life of Miriam, the sister of Moses and an important figure in Israelite history. In Exodus, she stars as a heroine, assisting in God's redemptive plan. In Numbers, the tables turned as she pitted herself against God's appointed leader. However, in both her shining and devastating moments, God's grace is ever-present.

READ EXODUS 1:1–2:10. As you get into Exodus 2, write down your observations about Miriam. (Note: She's just referred to as the "sister" here.)

To fully appreciate Exodus 2, we must look back at the horrific events of Exodus 1. While Pharaoh was hyper-focused on killing Hebrew sons to prevent the nation of Israel from growing in power, God used a Hebrew daughter, Miriam, and her mother, Jochebed, to secure a liberating future for Israel. (Neither woman is named in Exodus 2 but both are identified later in Numbers 26:59.) In wisdom and faith, Jochebed prepared a basket for her baby and strategically placed him in the Nile near Pharaoh's daughter's bathing site, hoping he would be saved.

In verse 4, we are introduced to the baby's sister, Miriam, standing at a distance and waiting "to see what would happen." When an opportunity to protect Moses presented itself, she acted. At the end of Exodus 6, we learn that the child Miriam protectively watched over and secured safety for would become the one "whom the LORD told, 'Bring the Israelites out of the land of Egypt'" (Ex. 6:26). Her intervention helped make a way for the salvation of all of Israel.

How do you see God's grace (unmerited favor) at work in the story of Moses's birth?

NOW SKIP AHEAD, AND READ EXODUS 15:1-21.

We've skipped some chapters here, and *a lot* has happened to lead up to this song of praise. (If you have time, it's worth reading today.) Exodus 14 describes how Pharaoh's decree to drown all the Hebrew boys in the Nile became his own fate, and Israel was saved up out of the water, just like Moses was. This act of God's perseverance and protection had a huge impact on the Israelites. Israel referred to Yahweh as "my God" (15:2). He was no longer just the God of their forefathers. They had a new awareness of His presence and power.

> READ EXODUS 15:20-21 AGAIN. How does Miriam describe God? How do things like your worship and your prayers change when you remember He is "highly exalted"(v. 21)?

An important part of Miriam's role as prophetess would have been leading the people of Israel in worship, which we see her doing here. This moment was the consummation of centuries of Israel waiting and watching for God to work. Now eighty years after Moses's birth, Miriam witnessed the salvation of the Lord. The story of Israel's salvation from Egypt reminds us of God's faithfulness to His promises and points forward to the salvation from sin available in Jesus.

> NOW READ NUMBERS 12. What stands out to you about Miriam from this part of her story? In your own words, what was wrong with the question asked in verse 2?

Though it's clear that Miriam was a prophetess greatly used by God in her community, Moses's personal relationship with God and the authority he was given were hard for Miriam and Aaron to accept. Miriam's comments about Moses's wife's ethnicity were a smoke screen for the real issue—envy of Moses. She felt she was entitled to more attention and more authority.

How did God address Miriam's pride and entitlement (vv. 6-10)?

Miriam and Aaron angered the Lord, because their questions of Moses were ultimately a question against His purpose and authority. Verse 9 says God's "anger burned against them," and He withdrew His presence from the tent of meeting. Then in verse 10 we read He gave Miriam a skin disease like leprosy. Miriam became unclean and needed to be removed from God's covenant community.

Although both Miriam and Aaron spoke out against Moses, only Miriam was punished. Some scholars believe this is because it was her idea, given that verse one names her first.[2] Others add that Miriam was the only one punished because Aaron's priestly status required him to remain clean, which Miriam now was not.[3] And then others see in this part of Miriam's story a comparison with Zipporah, Moses's wife (Num. 12:1), and the picture both women give us of God's grace for all people, both Jews and Gentiles alike.

READ EXODUS 34:5-7. How do you see God's words concerning Himself prove true in Miriam's story? How have you seen them proven true in your own story? What part does Jesus play in that?

At first glance, God's response may seem harsh. However, it's quite the opposite. His comments are filled with grace as He reveals His covenantal relationship with Miriam as Father and assured her brothers that her banishment was temporal, not eternal. While not "leaving the guilty unpunished" (Ex. 34:7), He still extended grace and compassion, restoring Miriam to His covenant community and relationship with Him.

Like Miriam, we all have a highlight and lowlight reel. Unlike Miriam, as Christians, we don't have to bear the punishment for our sins. Christ has taken upon Himself the guilty punishment we deserve, and His atoning sacrifice is so efficient that even when we sin, His grace continues to cover us. Instead, His Word says, "If we confess our sins, he is faithful and righteous to forgive us our sins and to cleanse us from all unrighteousness," so that we can continue to live in uninterrupted fellowship with Him (1 John 1:9). We will sometimes get it right and oftentimes get it wrong, but either way, we can always rest in God's amazing faithfulness and grace.

DAY 03

Rahab

TESTIMONY OF GOD'S POWER

by Sarah Humphrey

Rahab's story is found in Joshua 2 and Joshua 6. She is best known for being a prostitute in Jericho and sheltering two Israelite spies. Rahab is also mentioned in Matthew 1:5; Hebrews 11:31; and James 2:25.

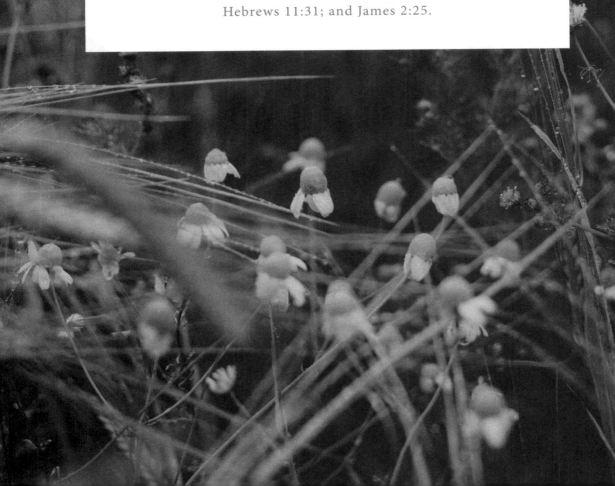

I've always rooted for the underdog, perhaps because I've been one for most of my life. Underdogs have a grit and determination to thrive, succeed, and live that outweighs others who have had opportunities to coast through their days.

We've all seen the beauty, strength, and success of those who have grown from family lines of godly righteousness and education. They are wonderful resources of wisdom! Yet those who were raised with a mess to clean up, with physical limitations, or with astonishing courage in the face of adversity always reveal a unique tenderness from the heart of God. Throughout Scripture, we repeatedly see Him purposefully choose world changers from those who have failed, those who are disadvantaged, and those with repentant yet shattered hearts.

Such might have been the case with Rahab. We don't know much about her, but what we do know we learn in the book of Joshua.

READ JOSHUA 2, and write down what you learn about Rahab.

When we dive into Joshua 2, we read about a woman named Rahab who is described as a prostitute who lived in Jericho, a city on the edge of Canaan in the promised land. We know she had a family that included parents, brothers, and sisters, that she lived in a house, and that she believed what she had heard about the power of Yahweh, Israel's God. Beyond that, we don't know about her personal life or family history.

Now write down your observations about the two travelers who ended up at Rahab's house. Consider: Why were they there? What did Rahab do for them, and why? What did they promise her in return? What were the conditions of the agreement?

Rahab hid in her home two Israelite spies sent by Joshua to scout out the land and get a sense for how they could conquer it. When word reached Rahab that these two spies were to be captured by the king, she courageously hid the men and then manipulated the plans of the enemy so their lives would be spared and the plans of God would prevail. In exchange for her protection, the spies promised they would protect Rahab and her family when the Israelites conquered Jericho.

READ HEBREWS 11:31. What additional insight do you learn about Rahab from this verse in the New Testament?

From your reading of Joshua 2, how did Rahab know about the God of Israel? What does this reveal about how and why He works in miraculous ways?

The writer of Hebrews included Rahab in his list of people of exemplary faith for her belief in God and protection of His people. From Joshua 2:10-22, it is evident that word of God's miraculous work to lead Israel out of Egypt had spread throughout the land. Based on God's power and protection of His people, Rahab believed in Him. She chose to protect God's men, believing that righteousness would prevail.

NOW READ THE REST OF RAHAB'S STORY IN JOSHUA 6:22-27.

After the city was defeated, what happened to Rahab and her family (vv. 22-25)?

In a scene that fulfills many of God's promises to the nation of Israel and puts the power and glory of God on display, the Israelites conquered Jericho. Joshua upheld the oath the spies had made with Rahab—her family was protected, and they became a part of the covenant community of Israel. Just look at the ramifications of Rahab's protective act! She played a part in saving the lives of her family, protecting the nation of Israel, and fulfilling the promises of God.

READ MATTHEW 1:1-17, FOCUSING ON VERSES 5-6.

Here we are again at Matthew's genealogy of Jesus, which now includes Rahab. From this genealogy, what do we learn happened to Rahab after the conquest of Jericho?

Rahab, a woman best known for being a prostitute and a Canaanite, played a prominent place in the history of God's people and is included in the earthly lineage of Jesus Christ, the Messiah. Rahab became the mother of Boaz (the kinsman redeemer from the book of Ruth). This means she was also a great-grandmother in the lineage of King David, and therefore Jesus.

God reveals His love for us through the lives of people in the Bible who point us to Christ. God's Word documents for us His redemptive and restorative plan through the messiness of humanity. As you move forward through your days and nights, remember the story of Rahab's faith. No matter what has happened in your past, there is repentance, grace, and purpose for each one of us as God's children in Christ.

Before finishing today's study, spend time in prayer reflecting on the gift of Rahab's story. How does the story of Rahab encourage you in your devotion to God?

DAY 04

Deborah

MODEL OF GOD'S WISDOM

By Jaclyn S. Parrish

Deborah's story is found in Judges 4–5. She is best known for being the only female judge and prophetess of Israel during the time of the judges.

Irony occurs, in life and in literature, when expectation and reality are unaligned. For example, one would expect a wedding day to be bright and sunny, and so rain on your wedding day would be ironic. One would expect a great general to die gloriously in legendary combat, so having one go out with a tent peg through his temple would be, among other things, ironic. But believe it or not, that's a scene we'll encounter today.

Deborah's story from the book of Judges is an invitation to reexamine our expectations and to rethink what we believe is possible. And it's another reminder that God is always behind the scenes in the story of Scripture, advancing His purpose and expanding His kingdom.

READ JUDGES 4:1-3.

This story starts like practically every chapter of Judges. God's people fail. Again. Punishment comes. Again. They come to their senses and cry for help. Again. And again. And again. (Take a moment to skim backward and forward to see this pattern, if you have the time.) Judges is an action-packed book, a cinematic supercut of grand armies, midnight missions, and secret assassinations. One chapter before, Ehud impaled a king and left him to bleed out in the bathroom. One chapter after, we'll see Gideon haggling with God for proof of whom he was talking to.

Amidst the episodic drama, we can easily miss how truly boring the overarching narrative is. The same story arc loops, on repeat, for generations. The same nation breaking the same promises. The same leaders ignoring the same warnings. The same people making the same mistakes.

What painful patterns are you currently experiencing or observing in your own life? List one or two of them here.

READ JUDGES 4:4-10. What stands out to you in these verses?

The episode continues as per usual, with God raising up a judge to cast out Israel's enemies. But already, the tropes are out of joint. For starters, the judge was a woman this time. Indeed, the author of Judges is matter-of-fact and unflinching on that

point: "Deborah . . . was judging Israel at that time" (v. 4), she held court in a public place (v. 5), she summoned men when she had a message for them, and she spoke explicitly on behalf of the Lord (v. 6). In verses 6-7 we're told about her summons of Barak to lead her army, but his response seems unexpected, even churlish: "If you will go with me, I will go. But if you will not go with me, I will not go" (v. 8). Was he putting stipulations on his obedience? Defying this prophetess?

READ HEBREWS 11:32-34. What do you make of Barak being included in this list?

Biblical commentator Michael Wilcock reminds us that Barak's presence in Hebrews 11's "hall of faith" merits him some benefit of the doubt. He points out that Barak's declaration simply echoes that of Moses when the people of Israel were told they would enter the promised land without God's presence: "If your presence does not go . . . don't make us go up from here" (Ex. 33:15). Barak insisted on Deborah's presence because he recognized her as a legitimate representative of his Lord, and because he knew he needed the Lord's presence.[4]

All in all, the Scripture paints for us a picture of a woman who led with confidence, commanded respect, and carried out her duties under the authority of the Almighty. And the irony only continues, for not only did this woman calmly agree to march into battle, but she predicted that a woman would best the general they went to fight. Odd. God doesn't seem to be playing by the rules.

Refer back to the painful patterns you listed on the previous page. How are you expecting God to solve them? Is there anything you've given up praying about because you no longer expect God to act? If so, note it here.

NOW READ JUDGES 4:11-5:31.

Consider a few of the cultural expectations inherent in this passage's context: battles are won by men on the battlefield; men are the ones who speak on God's behalf; Jael is the wife of Sisera's ally, and therefore subject to her husband's political alliances; God works through His own people, Israel; non-Israelites are not friendly with

God's people or welcome among their ranks; the laws of hospitality necessitate the utmost respect for guests. Judges 5 retells Deborah and Jael's story in verse, and the shift in genre only highlights additional ironies. In short, God knows our expectations, but He has His own plans.

> When you think about Deborah's role among the nation of Israel, how do you see her pointing forward to Jesus?

How amazing that Deborah, a woman, follows in Moses's footsteps as a spiritual leader for the people of Israel, a line of prophets that the apostle Peter later connects to Jesus: "Moses said: The Lord your God will raise up for you a prophet like me from among your brothers" (Acts 3:22). In Deborah, we also see foreshadowing to Christ as Victor, the One who defeats the ultimate enemy of God.

We know that, in the end, God will make all things right and make all things new. But in the meantime, hope can be exhausting. Deborah and Jael's story challenges us to adjust our expectations, to remember that God is sovereign and acts as He wills. The odds mean nothing to Him. Probabilities crumble under the weight of His glory. He can move powerfully, in the most unexpected ways and in the most hopeless cases, and He is always victorious.

> Look back at the expectations you've set for how God will or should answer your prayers and the things you've stopped praying about. Why do you assume these are the ways God will or should answer you? Why do you no longer expect God to move?

Consider your responses to that last question as you spend some time in prayer. Ask God to move powerfully in this situation, and ask Him to open your eyes to how He is already at work there.

Naomi & Ruth

REFLECTIONS OF GOD'S LOVE

By Nancy Comeaux

Naomi's story is found in Ruth 1–4. She is best known for being Ruth's mother-in-law and renaming herself "Bitter" because of the tragedy in her life.

Ruth's story is found in Ruth 1–4. She is best known for her faithfulness to Naomi and Naomi's God and her relationship with Boaz. She is also mentioned in Matthew 1:5.

In doing some research into my family tree lately, I've learned about some "good fruit" and some "bad fruit." I've found a relative who was murdered at a bar one night, one who was a prisoner of war, and then one who gave part of his land to build a local church. I've learned about mothers whose children didn't make it to adulthood, sisters who longed to see their warring brothers come home alive, and grandmothers who worked night and day to make sure their families were fed and clothed.

It's amazing how God can redeem any person—regardless of their circumstances or choices—and do wonderful things with that person's life. Today we're doing a fly-over look at Ruth and Naomi, who get an entire book of the Bible dedicated to their story. But really, like all the women we're considering, it's God's story. God's redemptive work is threaded throughout the book of Ruth from beginning to end. Watch for it as you read.

> **READ RUTH** 1. Write down two things that stand out to you as you read.
>
> 1.
>
>
>
> 2.

Bethlehem, which means "house of bread," faced a famine. Elimelech and his wife, Naomi, took the solution to their family's hungry stomachs and empty storehouses into their own hands. Instead of waiting on the Lord to sustain their needs in this promised land, they took steps in the wrong direction and sojourned to the pagan town of Moab. (Check out Gen. 19:30-38 for history on the Moabites.)

In Moab, Elimelech died and his two sons disobediently married women from that region. After a decade as couples, the two sons died also—without any heirs. Left now were three heartbroken and probably terrified widows, a class of people who at that time were considered to be among the most disadvantaged, often living on the generosity of strangers. The daughters-in-law were full of love for Naomi and initially set on the return to Bethlehem with her, but after a touching goodbye, Orpah hesitantly took Naomi's advice and returned home. However, Ruth determined to stay with Naomi and travel with her to the blessed Bethlehem, now ripe with sustenance.

Think about Ruth's time in Naomi's family. How might Ruth have been exposed to the God of Israel over time?

Describe Naomi's relationship with God when she arrived in Bethlehem.

Ruth desired the same people and God Naomi prayed to and served. When they arrived back in Bethlehem, Naomi (which meant *sweet*) changed her name to Mara (which meant *bitter*) because of the place she now found herself in. Life had been hard on Naomi, and it put a strain on her relationship with God.

Describe a time when you have felt like Naomi.

Ruth 2:1–4:17 record the events that happened to Naomi and Ruth once they settled in Bethlehem. It was barley season, so Ruth asked and received Naomi's permission to glean in the fields and gather some grain (2:1-2). This was a practice commanded by law for the provision of the poor; Ruth and Naomi would have been dependent on the practice for survival. As grace would have it, Ruth gleaned in a field owned by a wealthy man named Boaz, a relative of Elimelech (2:3). Boaz saw Ruth and inquired about her. When he found out she was Naomi's daughter-in-law, he commanded that she be provided for and protected in the fields (2:5-13). Boaz was impressed by her devotion to Naomi and her willingness to give up her home and follow her mother-in-law's customs and religion.

LOOK MORE CLOSELY AT RUTH 2:20-23. ALSO READ LEVITICUS 25:25,47-49. What was the function of a kinsman redeemer in Israelite law?

How do you see God's redemptive work behind the scenes in the lives of Naomi and Ruth?

The laws of that time proclaimed that a kinsman redeemer was a male relative who had the responsibility to help or redeem in a time of need—mainly to redeem the land, marry the widow, and produce an heir so the family name would continue on in Israel. Naomi had a plan. She noticed how attentive Boaz was toward Ruth and suggested she approach him and appeal to his heart to be her kinsman redeemer, a role he was able to take on because of his relation to Elimelech, Naomi's husband. Ruth followed through with Naomi's plan and approached Boaz to be her family's redeemer (Ruth 3:1-9). Ruth 3:10–4:12 describe the events that followed as Boaz went through the necessary steps to become their kinsman redeemer.

READ RUTH 4:13-22 AND MATTHEW 1:1-17.

Boaz bought the land from Naomi (4:9), married Ruth, and fathered a child provided by the Lord—Obed. Naomi cradled this new life in her arms and touched the tiny fingers and toes that made her into a blessed grandmother.

Who was Obed's paternal grandmother (Matt. 1:5) ?

Who was Obed's grandson?

This is not the first time we've come across Jesus's genealogy in the stories of Old Testament women. Are you starting to see a pattern? Once again, God used an unexpected woman—here a Moabite widow—to play an important part in His story. Ruth's son Obed became the father of Jesse, and Jesse became the father of King David. And David's lineage led the way to the Messiah and the salvation available to all people.

With the birth of her grandson, the women of Bethlehem blessed Naomi. God's grace again and again covered the heart of this woman and her family, and through her family came a lineage of believers that culminated in the ultimate Kinsman Redeemer—Jesus.

Are you surprised by any parts of Ruth and Naomi's story?

What encourages or challenges you about what you've read?

No matter the circumstances, God can forgive you and use you to tell His story to generations of women in your life or in years to come. Thank God for using people who sometimes seem hopeless. Ask Him to show you how you can share His love with the women around you today.

IF YOU HAVE TIME TODAY OR LATER THIS WEEK, READ RUTH 2–4 and fill in the chart.

Bible Passage	People	Problem	Solution
Ruth 2:1-23			
Ruth 3:1-18			
Ruth 4:1-12			

Once again,
God used an

*unexpected
woman*

to play a part in
His story.

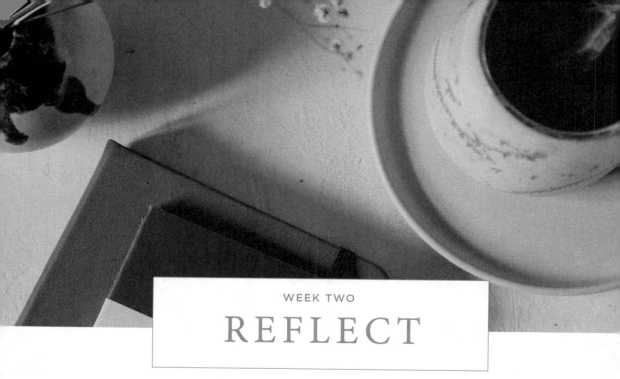

REFLECT

Tamar, Miriam, Rahab, Deborah, Naomi & Ruth

Take a few minutes to reflect on the truths you uncovered in your study of God's Word this week. Journal any final thoughts below, or use the space to take notes during your Bible study group conversation. The three questions on the opposite page can be used for your personal reflection or group discussion.

Download the *Devoted* leader guide at lifeway.com/devoted

As you reflect on the Bible passages you read this week,
what stands out to you about the character of God?

How have you been challenged and encouraged in your relationship
with Jesus through the Scripture you studied?

Write down one way you can use what you've
learned this week to encourage someone else.

Week Three

HANNAH • ABIGAIL • BATHSHEBA
HULDAH • ESTHER

Hannah

TRIUMPH OVER SHAME

By Kristel Acevedo

Hannah's story is found in 1 Samuel 1–2. She is best known for her example of prayer and being mother to the prophet Samuel.

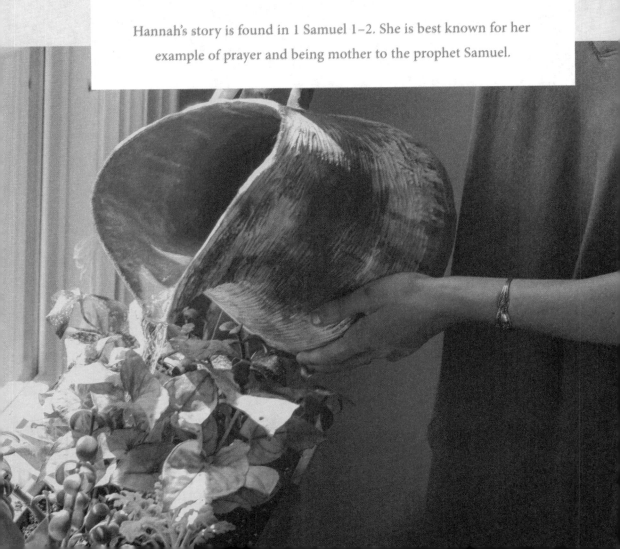

Shame is a feeling we are all familiar with. You might feel shame about a decision you made. You knew it wasn't the right choice, but you did it anyway. You might feel shame because of something that was done to you. Someone you trusted wronged you. It wasn't your fault, but now you carry complicated feelings wondering if there is something you could have done to prevent the situation. You might even feel shame over something you have absolutely no control over—your family of origin, your body type, or your medical condition. That last example is where Hannah found herself when we read about her in 1 Samuel 1.

READ 1 SAMUEL 1:1-11. What details do you learn about Hannah and her family from the opening verses of 1 Samuel?

When we meet Hannah, we see that she lived in shame because, despite her many prayers, she remained childless in a time when often the only worth women brought to the table was their fertility. Being childless was considered to be a curse (Gen. 16:2; 20:18). Hannah had an adoring husband who loved her so much that he favored her in the food distribution, but his other wife ridiculed her for being unable to carry a child. Hannah's pain is palpable in these verses.

REREAD 1 SAMUEL 1:10-11. List the words used by and about Hannah that describe her emotional state. How would you describe her relationship with the Lord?

In the midst of her grief and shame, Hannah turned to the Lord. In her desperation, she went to the Lord's temple and made a vow through her "bitter" tears. The CSB translation uses words like *depth of my anguish* and *resentment* to describe her. Hannah desperately wanted a child, but in her prayer she promised that if God granted her desire for a son, she would return him to the Lord so that he could serve God for all the days of his life. By committing the life of her not yet conceived child to God, Hannah acknowledged the gift from God that child would be.

Often we, like Hannah, must come to the end of ourselves to realize our true need for God—to surrender to Him our desires, our abilities, and everything we thought was best. In Hannah's anguish, she came to experience God in a unique way that would lay the foundation for Samuel's life.

READ 1 SAMUEL 1:12-28. What catches your attention here? What did Hannah do after she was done pouring her heart out to the Lord? How do you imagine she felt?

As we continue in Hannah's story, what I notice is that nothing changed right away. Hannah finished praying, spoke with Eli the priest, and went home. The next morning, she worshiped with her husband. Even though her circumstance had not changed—she was still childless—Hannah worshiped the Lord. Maybe you share Hannah's pain of childlessness, either the struggle to conceive now, the official word it will never happen for you, or the reality that it never came to be. I pray you don't miss 1 Samuel 1:18: "Then Hannah went on her way; she ate and no longer looked despondent." Peace in the Lord and His plans for you comes from being in His presence.

We all have situations in our lives that we wish would change, don't we? We think if only this one thing would go our way, then everything would be better and then we could really trust God with all the details of our lives. But that's not how Hannah acted. Fully convinced of the Lord, His character, and His power, she chose to worship in the midst of her pain. What would it look like for you to trust God with every painful circumstance of your life? Perhaps you would know peace that transcends all understanding and be able to worship as Hannah did. This type of surrender comes when we know who God is—a loving Father who is good and fully in control.

What are some of the characteristics of God that come to mind when you think about what you've read over the course of your *Devoted* study so far? Write those words down here, and consider how knowing those aspects of God's character can bring peace and comfort to your pain.

NOW READ 1 SAMUEL 2:1-11. As you read through Hannah's prayer, compare it to her original prayer in chapter 1. What changed? What stayed the same?

Underline in your Bible or list here every word/phrase Hannah used to describe God in 2:1-10. Then write a statement summarizing your takeaway from her prayer.

Hannah's joy leaps from the pages of her triumphant prayer. Her song tells of a heart that rejoices in the Lord. What she walked through with the Lord was deeply impactful, and she simply couldn't contain it. Hannah's prayer holds striking similarities with the Magnificat, Mary's declaration of praise at her pregnancy with Jesus. In Luke 1:46-56, Mary uses Hannah's words to voice her own song about the faithfulness and power of God. In this way, Hannah and Samuel point us forward to Mary and Jesus.

As God's daughter, you can rest assured that God sees you and knows you. There is a purpose for every painful circumstance you walk through, even if you don't know what it is. For Hannah, her pain brought her to a place of complete trust in the Lord. And when she gave birth to a son, Samuel, she was faithful to the promise she made to God, and her son went on to become a great prophet of Israel. Both Hannah and Samuel served God faithfully.

You may not be able to know or understand the end of the story quite yet, but you can trust that you are never alone and that the Prince of Peace (Isa. 9:6) guides your every step.

Take some time today to journal your own prayer like Hannah's. Pour your heart out to Him, voice statements of trust and praise, use some of Hannah's words, and allow the Holy Spirit to direct you on how to trust God with the outcome of your pain.

DAY 02

Abigail

CROWNED IN RIGHTEOUSNESS

By Kelly D. King

Abigail's story is found in 1 Samuel 25. She is best known for being a wife of King David. Abigail is also mentioned in 1 Samuel 30; 2 Samuel 2; and 1 Chronicles 3:1.

I met Lauren a couple of years after she relinquished the coveted crown of Miss America 2007. Today, Lauren is a mom of three children, a ministry wife, and the host of a television show. And while her day-to-day life looks like a lot of women, she will always have the unique distinction of being Miss America. During my years in women's ministry, I've also worked with a few other godly women who have won pageant competitions. They are poised and articulate. If you ask them a difficult question, you will often get a wise and intelligent response. Their experience and training have prepared them beyond competitions and equipped them for a life of devotion to the Lord.

Esther often comes to mind when identifying a queen in Scripture, but I think Abigail deserves more recognition than she receives. Like the pageant queens I've been able to partner with in ministry, Abigail breaks the mold. Her story in 1 Samuel 25 shows us a woman with courage and faith whom God used in a very specific way.

READ 1 SAMUEL 25:1-13. Note next to each name what you discover about the following people.

Samuel	
David	
Nabal	
Abigail	

If you have a few extra minutes, it would be helpful to read over 1 Samuel 18–19 to get some context for chapter 25. Chapters 18–19 describe David's rise in power and the diminishing power of King Saul. Mourning the death of Samuel and fleeing from a jealous King Saul, David found refuge in several desert regions, including Maon, the area where Nabal and Abigail dwelt.

The beginning of 1 Samuel 25 paints a striking contrast between Abigail and her husband. Nabal is described as "harsh and evil," while Abigail is described as "intelligent and beautiful" (25:3). The Hebrew root word used to express Abigail's intelligence is the same one used to describe David as successful in 1 Samuel 18:5, meaning they were both good of understanding, prudent, and insightful.[1] Not only was Abigail beautiful in her appearance, but she was wise.

REREAD 1 SAMUEL 25:4-13. Summarize the issue that arises early in this chapter.

The first thirteen verses describe the conflict that developed between David and Nabal. Shearing sheep occurred twice a year, and David instructed his men to act as security for Nabal's servants and animals. As a Calebite, Nabal was part of the tribe of Judah, meaning he was a kinsman to David. David gives instructions to his young men to receive appropriate payment for their services, yet Nabal refuses. The result? An angry, self-centered Nabal and a vengeful David.

READ 1 SAMUEL 25:14-31. Name the specific things Abigail did in these verses:

verse 18

verse 20

verse 23

verses 30-31

These verses reveal Abigail's shining moments and the longest speech given by a woman in the Old Testament.[2] We find her intervening in a volatile situation and diffusing a conflict. Abigail's initiative and independence were certainly rare for a married woman during this time and in this culture. In this case, it was downright scandalous since it entailed a covert meeting with one of her husband's enemies. Nevertheless, she did three remarkable things in her actions: 1. she interceded on behalf of Nabal, taking the blame that rightfully was his; 2. she prophesied David's future destiny as king; 3. she prevented David from bringing judgment on himself. She also referred to "the LORD" or "God" seven times in verses 26-30.

When Abigail successfully prevented David from taking vengeance as his own, she kept him from sin, at least temporarily. Abigail's story gives us the first picture of David's own shortcomings, and the story ends with him taking additional wives, which will eventually lead to his downfall.

> REREAD 1 SAMUEL 25:26-30. Underline each time Abigail spoke about God and His ways.

> NOW READ 1 SAMUEL 25:32-42. As you read, circle the specific word David used to describe Abigail.

David accepted Abigail's gift and words of wisdom, and she returned home to find a drunken Nabal. Her self-restraint is another indication Abigail trusted in the Lord and didn't take matters in her own hands. At daylight, and when Nabal was sober, she shared what she had done. Then Nabal died. No matter how he died, Scripture is clear, "The LORD struck Nabal dead" (v. 38). In the days that followed, David realized Abigail was more than a peacemaker; she was a godly woman he wanted to marry.

> Like Abigail, in what ways can you take your focus off yourself and focus on God's character as you seek peace in conflict? Write down some specific ideas that come to mind.

There are many glimpses of Jesus in Abigail's story. When we align ourselves as the rightful heir of Christ, He brings us in as His church so that we can serve Him and abide with Him forever. Abigail took the blame for Nabal's sin, which reminds us of how Christ took the blame for our sin on the cross. Plus, her wise mediation of an imminent conflict is an example for all of us to be peacemakers in a culture of conflict. Abigail is a godly example of a woman devoted to God, a woman who trusted He would provide and protect her.

You and I look in the mirror each day and consider whether we will reflect our heavenly Father amid our lives. May you be a woman devoted to God who wears a crown of righteousness made possible through Christ. Pray and ask the Lord to help you look more like Him today.

DAY 03

Bathsheba

RESTORED TO HOPE

By Ravin McKelvy

Bathsheba's story is found in 2 Samuel 11. She is best known for being the victim of David's adultery and the mother of King Solomon. She is also mentioned in 2 Samuel 12:24; 1 Kings 1; and Matthew 1:6.

Recently I've been walking with a dear friend through a difficult season in her life. It has wreaked havoc on her family and caused her much emotional pain. We've spent countless hours praying and processing together, and one of the most difficult things for me to come to terms with is the lack of control both of us have over the situation. Dealing with trials that are a result of our own doing is one thing, but when they are a result of the sin of another or of simply living in a fallen world, it can bring a different level of devastation. There have been many times when my friend and I are talking that I am reminded of the story of Bathsheba.

READ ALL OF 2 SAMUEL 11, THEN REREAD 11:2-5. In your Bible or in the list below, circle the verbs that are connected with David in 2 Samuel 11:2-5. Underline the ones connected with Bathsheba. (This list comes from the verbs in the CSB translation.)

GOT UP	PURIFYING	CAME	SENT
SLEPT	SAW	RETURNED	STROLLED

What stands out to you when you compare the actions of David with those of Bathsheba?

As you read in the passage, when we first find Bathsheba, she was bathing on the roof. From what we can tell from the passage, she was obeying the Old Testament laws of purification, the ritual of cleaning required after a woman's menstrual cycle (v. 4). Evidence in the text points to David seeing and lusting after Bathsheba, and then calling her to sleep with him. If you read on in 2 Samuel 12, you'll learn that the prophet Nathan condemned David's actions, and David later confessed that he had sinned (2 Sam. 12:13). Unfortunately, David's repentance didn't happen before his sin caused profound damage in her life.

NOW READ 2 SAMUEL 11:6–12:23. What consequences stemmed from David's sin?

As David initially tried to cover his sin, it spread and led to death—the murder of Uriah, Bathsheba's husband (2 Sam. 11:17), the deaths of soldiers with him on the frontline, and then the death of David and Bathsheba's newborn child, who died in God's judgment of

David (2 Sam. 12:14-18). We aren't given details of Bathsheba's emotional state during this time, but we are told that she mourned the death of Uriah (2 Sam. 11:26) and that David comforted her after the death of their son (2 Sam. 12:24).

Thankfully, Bathsheba's story doesn't end there. And like her, our stories don't end in our trials. The Lord indeed sees our suffering and doesn't watch passively. As we look further into the life of Bathsheba, we see a beautiful example of how the Lord cares, restores, and redeems even the most devastating situations.

> Is there a hardship in your life or in the life of someone you know over which you have no control? What specific ways would you like to see the Lord redeem this trial or season?

> READ MATTHEW 1:1-17, FOCUSING ON VERSE 6. Other women have been mentioned by name in Jesus's genealogy. Why might Matthew have included this description of Bathsheba in verse 6, rather than naming her? We can only speculate, so write down at least one thought that comes to mind.

By now this genealogy should be growing more and more familiar to you. When you look closely at verse 6, you'll see Bathsheba, mentioned here as "Uriah's wife," a not so subtle reminder of David's sin in the midst of Jesus's genealogy. Bathsheba, the mother of Solomon, is a part of Jesus's bloodline. This is far from where we left her in 2 Samuel 12. We often recognize Bathsheba mostly by what may have been the hardest season of her life. But Matthew 1:6 reminds us that God brought fruit and joy out of that season, evidence of God's faithfulness in the midst of suffering. Though Bathsheba lost much, the Lord did not leave her there.

We'll never know all the ways God comforted and redeemed Bathsheba out of her grief and suffering. But we do know three ways:

1. The Lord restored to her a son, Solomon (2 Sam. 12:24-25);

2. Then God used her as an influential voice in her son being appointed as king over Israel (1 Kings 1:11-40);

3. And finally in Matthew 1, we see that Jesus came by the bloodline of David and Bathsheba through Solomon.

In the Bible, we read many stories like Bathsheba's where the Lord brings about goodness and His glory through painful circumstances. But when we are in the midst of suffering—when we have been plunged so deep into darkness that the light seems to be only a memory—how then do we fight against despair?

Bathsheba's account is not simply a story but a light of hope to which we can hold fast. We serve a God who has the capacity to transform the most tragic of situations to beautiful testimonies of His faithfulness. There wasn't a tear Bathsheba cried that the Lord didn't see; not a grief of which He didn't also carry the weight. The Lord doesn't simply watch over us in our pain; He walks with us in the midst of it. We don't have to pretend our suffering doesn't exist or let it give way to despair. We can hold on to the Lord as we face it head on.

READ 2 CORINTHIANS 4:16-18, aloud if you're able. Read it at a slow and reflective pace.

Therefore we do not give up. Even though our outer person is being destroyed, our inner person is being renewed day by day. For our momentary light affliction is producing for us an absolutely incomparable eternal weight of glory. So we do not focus on what is seen, but on what is unseen. For what is seen is temporary, but what is unseen is eternal.

The Lord not only redeemed Bathsheba's suffering, but He also purposed it to bring about the redemption of many through the birth of Jesus. As we cling to hope when we are in the midst of seasons of hardship, we must also remember that the Lord has generations in mind. Not only can He take our situation and redeem it, but He can use our testimony of dependence and hope to lead others into greater communion with Him.

In a journal or a note in your phone, write a poem or prayer processing the season of life you're in. Be intentional to end it by proclaiming the hope you have in Jesus no matter the circumstance. Hold onto this prayer so you can refer back to it whenever you need to.

DAY 04

Huldah

MESSAGES OF REDEMPTION

By Christine Thornton

Huldah's story is found in 2 Kings 22:14-20 and 2 Chronicles 34:22-28.
She is best known for being a prophetess in Judah during
the reign of King Josiah.

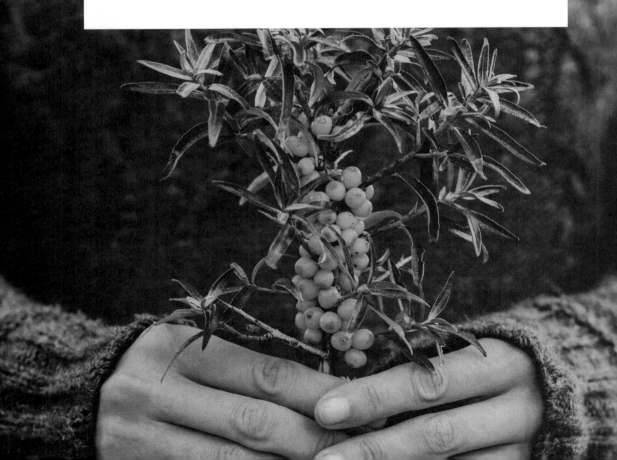

Sometimes after we've spent day after day reading in the Old Testament, we find ourselves longing to get to the New Testament and the advent of Jesus. Maybe you feel that way now after days of reading stories of the women of the Old Testament. Have you found yourself longing to read about Jesus? I hope the glimpses you've caught of Him along the way so far have encouraged you; we get another one of those today. This is a story about the history of Israel, but it's really a story about the gospel of the Lord Jesus Christ. As we learn about Huldah and Josiah, we'll behold Christ in all His glory.

> **BEGIN BY READING 2 KINGS 22:14-17 AND 2 CHRONICLES 34:22-25.** What do you learn about Huldah from these verses?

The single story we are told about Huldah shows up in two places in Scripture—2 Kings 22 and 2 Chronicles 24. Huldah plays an integral role in King Josiah's story. Unlike his fathers before him, Josiah walked the straight path of righteousness (2 Kings 22:2; 2 Chron. 34:2). He tore down idols and restored the temple (2 Chron. 34:3-8). During the temple renovation, the high priest discovered the Books of the Law—the first five books of the Old Testament (2 Kings 22:8; 2 Chron. 34:14). When Josiah heard the words, he recognized that the disobedience of his people had incurred God's wrath (2 Kings 22:11; 2 Chron. 34:19). So, he sent the high priest and some servants to inquire of a prophet about the matter (2 Kings 22:13; 2 Chron. 34:21).

Enter the prophetess Huldah. Like Moses, Miriam, Deborah, and Samuel before her, God spoke His words from her mouth. God always instructs His people by His word through human words. In this case, God did so by both His past prophet, Moses, in the Books of the Law, and His present prophet, Huldah. God's word through Huldah comes with weight and authority appropriate for God Himself.

> Summarize the first part of Huldah's prophecy in 2 Kings 22:16-17 and 2 Chronicles 34:23-25.

Huldah gave her prophecy, according to what was already written in the law. She gave a new word that echoes the old word of Moses. First, she told of the coming destruction of Judah because of their disobedience foretold in Deuteronomy 11:26-28.

> Look, today I set before you a blessing and a curse: there will be a blessing, if you obey the commands of the Lord your God I am giving you today, and a curse, if you do not obey the commands of the Lord your God and you turn aside from the path I command you today by following other gods you have not known.

Before they entered the promised land, God's people were given the choice to obey and be blessed or to disobey and be cursed. Disobedience against God always incurs His righteous punishment, or curse. Huldah proclaimed to Josiah and his kingdom that God would be true to His word, and their disobedience would be met with the curse of His righteous punishment.

Take a moment to reflect on your own life. Are you listening and responding to God's authoritative Word and choosing to walk the path of righteous obedience? Be honest in your self-reflection.

NOW READ 2 KINGS 22:18-20 AND 2 CHRONICLES 34:26-28. Summarize the remainder of Huldah's prophecy. Specifically, what did she affirm about King Josiah?

As Huldah finished the prophecy, she offered hope to King Josiah. Because Josiah heard the Word and repented on behalf of his ancestors, God would withhold His judgment for a time and promised Josiah peace until his death.

Think about the way King Josiah acted. How does his example point forward to the work of Jesus in your life?

Josiah, a king like David (2 Chron. 34:2), repented on behalf of his people for sins that he didn't commit, and God stayed His judgment. Jesus, the true Davidic King, repented on behalf of all people, though He Himself was sinless. While God withholds punishment from Josiah, the true Righteous King took upon Himself the curse of punishment that we all rightfully deserved. He was not given a death of peace to be gathered to His fathers, but died the violent death of wrath, betrayed and abandoned; He suffered and died alone. In His resurrection and ascension, Jesus offers to us the fate of Josiah. We are rescued from the day of disastrous wrath and enter His peace, gathered to our fathers and mothers, brothers and sisters who are alive in Christ, even though they have died. Jesus is the hope of Josiah's story.

> Now think specifically about Huldah's role in this story. How does her example point forward to the work of Jesus in your life?

Huldah delivered the good news of redemption to Josiah. From her lips, God spoke curse and blessing, destruction and hope, wrath and peace. Ultimately, Jesus is the true Prophet. He is the gospel Word spoken, and the human mouth that speaks it. He proclaims that judgment follows disobedience, but also that through His obedience unto death and glorious resurrection we can have life and peace. Thus, Huldah, as much as Josiah, reveals Christ and His own prophetic proclamation.

Huldah's story provides interesting insight into Israel's history, but more than that, it proclaims the gospel of the Lord Jesus Christ. He is the righteous King who reigns eternally on the throne of David, the Prophet who proclaims blessing and curse, and the High Priest who offers Himself as an atoning sacrifice for the curse of sin. As we reflect on Huldah and Josiah, we cast our gaze on Christ and marvel in wonder at the good news of life in Him.

> Are you trusting Christ as the righteous King who took the curse for you? Are you faithfully proclaiming the gospel to those around you? Take a minute to reflect on these questions as you pray. Remember the gospel. Speak the good news aloud or write it down in a journal or in your book. Use whatever words you are familiar with. If you aren't sure what to say, there's an example for you on page 164.

DAY 05

Esther

TRUST IN GOD

By Michelle R. Hicks

Esther's story is found in Esther 1–10. She is best known for being queen of Persia and for advocating before King Ahasueras (Xerxes) to save the Jews from execution.

After eating her lunch, my grandmother would watch what she called her "story," also known as a soap opera. She knew these characters. Occasionally, she would warn them of their bad choices in the moment. And sometimes we would remind my grandmother that these were not real people, only part of a story.

The book of Esther has all the drama of an intriguing story, and it is true. It records real events in the history of God's people. In fact, it's the final book in the history category of the Old Testament. Sitting at ten chapters long, the book is a captivating read. If you have time in your schedule today or later this week, I encourage you to read through the whole book or listen to it on an audio Bible app. We'll only be focusing on key moments from Esther's story today.

But first, some background! Long before Esther and the Persian Empire, God's people had grown careless in their obedience to God and turned away from Him. As a result, their punishment was exile in Babylon from the comfort and security of the promised land. Eventually, the Babylonian Empire was conquered by King Cyrus of Persia. He allowed the Jews to return to their homeland or stay in Persia. God worked His plans and purposes through King Cyrus to deliver His people from exile, a reminder for us that every human being is under God's authority, even those who don't know or believe in God. (See Isa. 45:1-7.) King Ahasuerus (also known as King Xerxes depending on your Bible translation) is one of the central figures in the book of Esther and was the grandson of King Cyrus.

READ ESTHER 1–3. As you read, fill in the chart below, noting the key things you discover about the people mentioned.

Name	His/Her Character	His/Her Relationship with God
King Ahasuerus (or Xerxes)		
Queen Vashti		
The king's officials/ counselors, Memucan		
Mordecai		

Name	His/Her Character	His/Her Relationship with God
Hadassah (Esther)		
Hegai		
Haman		

What do you learn about God through the events and people in the opening chapters of Esther?

One of the most interesting features of the book of Esther is that even though it is an important book in the Old Testament, and even though the Bible is the written revelation of God Himself, there is no direct mention of God in this book of the Bible. But His presence is threaded throughout the entire story. From the first three chapters alone, readers are reminded that God is sovereign. He is working even when we don't see Him or hear His name spoken. God was at work in Persia with Esther, and He continues to work in the world today. God's Spirit moves in the highest courts among kings and in the city streets among the vulnerable and marginalized.

At this point in Israel's history, the exile was over. God's people were free to return to their homeland; yet many remained in Persia. We can't know for sure why so many Israelites stayed, but perhaps they had grown accustomed to the culture of Persia. They were comfortable, settled, and content. It appears that even Esther had grown accustomed to the luxuries of the palace.

What are the temptations of comfort, freedom, and luxuries available in our culture that you find are pushing you away from God instead of pulling you toward Him?

We read that the "city of Susa was in confusion" in Esther 3:15. The decree was issued to annihilate God's people "on a single day, the thirteenth day of Adar, the twelfth month" (v. 13). Evil against God's people is nothing new. Since the garden of Eden, Satan has plotted against God's people. Haman's edict and his actions reveal a person with deep hate for the people of God.

Esther and Mordecai may have experienced confusion or struggled in their faith, but in Esther 4 we see a change in each of them. What are some ways you see Mordecai and Esther express a renewed trust and faith in God?

MORDECAI

ESTHER

Even though God's name wasn't spoken, Mordecai was confident in God's deliverance. He wasn't placing his hope in Esther but in God. And she was willing to give up her relationship, protection, and comfort with the king for God and His purposes, even if it cost Esther her life. She was devoted to God.

How does Esther's story fit into the greater story of redemption through Jesus Christ?

Like Mordecai and the Jews, we need a mediator. We need someone with access to God who will plead to Him on our behalf. Just as Esther goes to King Ahasuerus on behalf of the Jews, Jesus is our Mediator. Jesus didn't only risk His life like Esther; He gave His life to save us.

"Esther's story is a powerful reminder that God can bring about new life, redemption, and freedom even when it seems an impossible feat."[3] Esther did not have much to

say about how her life unfolded, but she was brave and a woman of character. She was devoted to God. Esther risked execution to protect her people—God's people. What Mordecai asked her to do as a mediator to the king could have been her end, but she rested in God's providence and trusted His promises.

NOW READ ESTHER 7:1-10 AND 8:1-8. How do you see Esther demonstrate humility in this passage? What does her humility teach you about God?

God "used someone who, due to gender, culture, and circumstance," was seemingly invisible and powerless.[4] God made her an instrument of His redemptive love. Even when His name is not mentioned, Esther's actions demonstrated her trust and faith in a sovereign God. As a result, God's people were saved, and the Festival of Purim continues even today as a celebration of His "saving power as recorded in the book of Esther."[5] (See Esth. 9.)

Esther's story demonstrates the providence of God—His authority, His kingdom, His sovereignty, and His glory. God moves and works through the ordinary lives of people. There is no plot or plan from Genesis to Revelation that can thwart God's purposes.

Think about your life. What is your story? What position has God placed you in, and how are you being used to further Christ's kingdom?

Pray about where God has placed you and your devotion to Him. Trust His providence and His sovereignty. Allow Him to create a beautiful story with your life for His glory.

Esther's story is a
powerful reminder that
God can bring about
new life,
redemption,
and freedom
even when it
seems impossible.

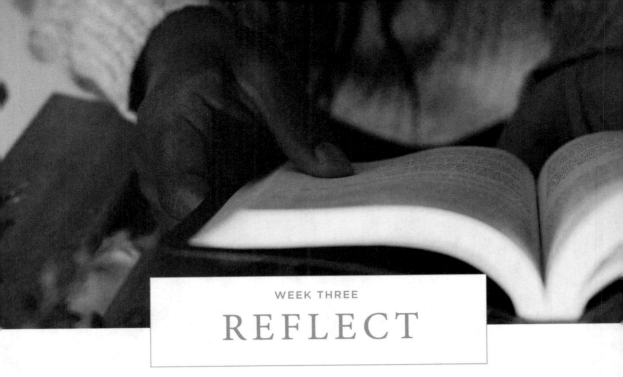

REFLECT

Hannah, Abigail, Bathsheba, Huldah, Esther

Take a few minutes to reflect on the truths you uncovered in your study of God's Word this week.
Journal any final thoughts below, or use the space to take notes during your Bible study group conversation.
The three questions on the opposite page can be used for your personal reflection or group discussion.

Download the *Devoted* leader guide at lifeway.com/devoted

As you reflect on the Bible passages you read this week,
what stands out to you about the character of God?

How have you been challenged and encouraged in your relationship
with Jesus through the Scripture you studied?

Write down one way you can use what you've
learned this week to encourage someone else.

Timeline

OF WOMEN IN THE BIBLE
BY BIBLE BOOK GENRE

EVE
SARAH
HAGAR
REBEKAH
RACHEL & LEAH
TAMAR
MIRIAM

RAHAB
DEBORAH
NAOMI & RUTH
HANNAH
ABIGAIL
BATHSHEBA
HULDAH
ESTHER

THE PENTATEUCH

OLD TESTAMENT HISTORY

*2200 BC – 1400 BC**

1400 BC – 465 BC

**Adapted from the CSB Lifeway Women's Bible (Nashville: Holman Bible Publishers, 2022). Dates and date ranges are estimates.*

ELIZABETH
MARY, *Mother of Jesus*
ANNA
JOANNA
A BLEEDING WOMAN
MARY *of Bethany*
MARTHA
The SAMARITAN WOMAN
MARY MAGDALENE

LYDIA
PRISCILLA

PHOEBE
EUODIA & SYNTYCHE
LOIS & EUNICE

DORCAS

THE GOSPELS

CHURCH HISTORY
(ACTS)

LETTERS

6/5 BC – AD 33

AD 33 – AD 70

AD 57 – AD 66

Week Four

ELIZABETH · MARY, MOTHER OF JESUS · ANNA
JOANNA · A BLEEDING WOMAN

Elizabeth

THE LONGING HEART

By Debbie Dickerson

Elizabeth's story is found in Luke 1. She is best known for being John the Baptist's mother and Mary's cousin.

I hadn't seen it in years until I stumbled across it the other day—my high school yearbook tucked away in my closet. Slowly, my finger found my photo and pointed to my bold aspirations set in print. I shook my head to think I had declared I'd be a computer engineer. It sounded good then, as did becoming an archeologist when I was eight. I am neither of those, unless finding artifacts in my closet qualifies me as an archeologist. So unfitting, those dreams were easy to close the book on. But not all longings have a short shelf life. I have a much harder time with prayers for healing, relationships, or loved ones to know God that seem to go unanswered. We all have longings that need no prompting from the pages of the past.

Somewhere on God's eternal timeline, two dots pinpoint His devotion to restore us to a right relationship with Him: His promise to send the Savior, the seed or offspring who would strike the head of the serpent is attached to one dot (Gen. 3:15), and His fulfillment of that promise in Jesus's birth, death, and resurrection is firmly nailed to the other (the Gospels). In between we see the Lord's sovereign plan unfold over a long line of history, moments of which you've examined over the past three weeks. The words that begin the Gospel of Luke make a tick mark on the timeline, breaking four hundred years of silence with the word of God.[1] At the corner of BC and AD, God's plan intersected with Elizabeth's.

READ LUKE 1:1-7. Verses 5-7 introduce us to Elizabeth and her husband, Zechariah. How is Elizabeth described in these verses?

Based on these verses, how did Elizabeth's longing for a child affect her relationship with God?

Luke described Elizabeth as being righteous and blameless, obedient to God's law. The same descriptions are used of Zechariah. Luke also pointed out that Elizabeth was born into the family of Aaron, Moses's brother and the first high priest, meaning the men in her family continued to serve as priests in the temple.

On the other hand, Elizabeth was barren, beyond her childbearing years. And regrettably, in her culture barrenness was often assumed to be a sign of God's disfavor.[2] From an earthly perspective, Elizabeth's righteousness was mismatched with disgrace. So, why did Elizabeth remain devoted to God when she could have become bitter? Her name gives us insight: *Elizabeth* means "my God is faithful."[3]

Amid their desire for a child, Zechariah and Elizabeth maintained a steadfast faith in God and continued to serve Him.

Think about a longing you currently feel is not being fulfilled. How is that longing affecting your relationship with God? READ PSALM 73:21-26, and ask God to counsel you.

Longings wear on our souls. While our lives may appear as unconnected dots, 2 Chronicles 16:9 assures us God has a sovereign vantage point: "The eyes of the LORD roam throughout the earth to show himself strong for those who are wholeheartedly devoted to him." And when we trust the Lord with our longings, His faithfulness leads us into a greater love, a deeper devotion.

NOW READ LUKE 1:8-17. Notice the words related to time and circle them in your Bible or list them here.

For hundreds of years God had been at work, orchestrating the events of history to lead up to the arrival of the Messiah, the Promised One. Even the fact that Zechariah was the priest in the temple that day was nothing short of a miracle. Each priestly division served twice a year for a week at a time and during major religious festivals. With an estimated eighteen thousand priests taking turns, Zechariah could only hope to enter the holy place once in his lifetime to offer incense.[4] Seeing he was chosen by lot at this time, we can trace God's hand in history.

The incense Zechariah burned in the temple symbolized the people's prayers rising to God.[5] As a devout Jew, Zechariah would have prayed for the coming Savior, but we can only wonder when he last prayed for a child of his own.[6] Verses 11-17 interrupt Zechariah's prayers with an angelic announcement: Two births—two answered prayers—were set in motion. The couple's longing would be miraculously connected to the promised coming of the Savior (Mal. 3:1). After years of silence, that must have been an earful! From Zechariah's response to the angel in 1:18 we gather it all sounded like too much; he doubted the things the angel told him could be true, and as a consequence, he lost the ability to speak until after the baby was born.

Label the left dot below with Elizabeth's longing and the other with God's answer. As you connect the dots with a solid line representing Elizabeth's life, consider how much greater God's plan was.

• •

NOW READ LUKE 1:18-25,39-45 AND 57-66. Notice Elizabeth's continued devotion. On the line you drew above, make three tick marks and label them with spiritual habits she demonstrated.

Focused on God, Elizabeth continued to worship and obey Him. He had not only answered her prayer for a child, but more wonderfully He had aligned it with the coming Savior who would remove her disgrace and the disgrace of all who trust in Him. Elizabeth's devotion to the Lord was lived out in her obedience, as she and Zechariah circumcised their son. Instead of naming him in honor of Zechariah, they honored God's command—despite the expectations of others—and named him John. Although our lives are outlined with longings, God never forgets our prayers, no matter how long it has been since we've put them into words. While we wait to see the bigger picture of His plans for us, we can remain devoted in the day-to-day by keeping our focus on God, worshiping Him, and obeying His Word, knowing He is faithful to fulfill His perfect plan.

Commit to remaining devoted to God by examining your own timeline. Pen your longing on the dot below. Then add a few tick marks with words you want to describe your waiting.

I'M LONGING FOR . . .

●————————————————————————————————→

Our longings lead to a deeper devotion when we trust God to faithfully fulfill His greater plan, not ours. Let Philippians 1:9-11 be your closing prayer of devotion today: "Heavenly Father, I pray my 'love will keep on growing in knowledge and every kind of discernment, so that [I] may approve the things that are superior and may be pure and blameless in the day of Christ, filled with the fruit of righteousness that comes through Jesus Christ to the glory and praise of God.'"

DAY 02

Mary, Mother of Jesus

THE FAITHFUL HEART

By W. Diane Braden

Mary's story is found in Luke 1–2 and Matthew 1:18–2:23. She is best known for being the virgin mother of Jesus. Mary is also mentioned in Matthew 1:16; 12:46-49; 13:55; 27:56; Mark 3:31; 6:3; 15:47; Luke 8:19; John 19:25; and Acts 1:14.

Imagine giving birth to a promise from God resulting in the life that saves the world from sin. It's honestly unimaginable, but Mary did just that as she brought forth our Messiah, Jesus. Mary and Joseph were given a task from God so extreme that an angelic announcement communicated the message to both of them, and Scripture tells us they walked out the task set before them in obedience to our heavenly Father.

As the days and even months passed after the angel appeared to Mary, her appearance would change as God grew the baby inside her. I can only imagine people pointing, whispering, and speculating, wanting the true story behind Mary's untimely pregnancy. What did that look like for Mary? How can one walk in dignity daily while no doubt shunned and even mocked? As we'll see today, the answer is in grace and faith. Mary believed that what God promised her and all His people would come to pass. Let's take a journey into Mary's story of unwavering obedience.

READ LUKE 1:26-38. This is a passage you may have read before, maybe many times depending on how long you've been a follower of Christ. What stood out to you as you read it today?

In the space provided, write out Mary's responses to each of the angel's statements.

Luke 1:29	
Luke 1:34	
Luke 1:38	

NOW READ LUKE 1:46-55. In your own words, summarize Mary's song of praise. Note the progression she has undergone from her initial response to the angel in Luke 1:29.

When we first met Mary, she was a teenage Jewish girl who was betrothed to a man named Joseph. But there was a change of plans or at least an added element to their story. Mary was chosen by God to be the mother of Jesus, the Son of God, our salvation (Luke 1:30-33). Visitations by the angel of the Lord to both Mary and Joseph (Matt. 1:18-25) revealed the masterful plan of God. Mary's response was shockingly selfless, although I can only imagine how she felt inside. She said simply, "I am the Lord's servant . . . May it happen to me as you have said."

REREAD LUKE 1:31-33, ALONG WITH JOHN 1:1-5,14. What truths are revealed about Jesus in these verses? List everything you observe.

Mary is carrying the Word. Jesus. The Light of the world. Once the Holy Spirit came upon Mary, "the power of the Most High" overshadowed her (Luke 1:35). She conceived the baby that would be born the holy Son of God.

READ ALL OF LUKE 2, which details the incarnation—the birth of Jesus, the Son of God—and the key events of the early years of His life. Write down three observations you have about Mary from these verses.

Mary brought forth the Savior of the World, Jesus, and in doing so she and Joseph raised Him in a manner pleasing to God. They brought Him to Jerusalem to present Him before the Lord, following the traditional Jewish customs. Simeon and Anna gave prophecies of this amazing child that He was indeed the Savior. Throughout His life, Mary would be there watching Him as He walked out the destined calling.

Luke 2:40 tells us, Jesus "grew up and became strong, filled with wisdom, and God's grace was on him." As a child, He taught religious leaders at the Passover festival (Luke 2:41-49). He said to His parents when they came looking for Him, "Why were you searching for me? . . . Didn't you know that it was necessary for me to be in my Father's house? (v. 49)" Mary was a mother who would suffer loss but with an end result of significant gains. She watched her Son go through hardness, trials, and ultimately a horrific death on the cross. She experienced the darkest, dimmest moment a mother could ever face. She couldn't be His savior, because He was hers. But she did not leave His side. She was faithful until the end of His earthly life, and she had a front-row seat to the Son of God's time on earth.

> READ MATTHEW 27:32-56; MARK 15:42-47; AND
> JOHN 19:25-30. As you read the events of the crucifixion, imagine
> them from Mary's perspective. Record your observations here.

John 19:26 tells us, "When Jesus saw his mother and the disciple he loved standing there, he said to his mother, 'Woman, here is your son.'" Jesus held death off long enough to acknowledge her and release her to the care of John. What Mary couldn't see in that moment was that Jesus would rise from the dead on the third day. She would see her Son again, and we can only imagine the joy, love, and thanksgiving that overwhelmed her when she did.

> Based on what you've read today and throughout *Devoted*, why
> do you think God chose Mary to be the mother of the Son of God?
> READ MATTHEW 1:16-17 AND LUKE 1:30 as you consider this.

The only clue we have from the text as to why God chose Mary to be the mother of the Son of God is that she had "found favor with God" (Luke 1:30). We know from His genealogy in Matthew 1:16-17 that Joseph had the pedigree to be the earthly father of the Messiah (2 Sam. 7); he was a descendant of Abraham and a descendant of David.

From the beginning of the Bible (Gen. 3:15) and the beginning of this Bible study (Eve, p. 10), we've seen God pave the way for His Son to come into the world to redeem broken humanity from our sin and bring restoration back to the world. With Jesus's birth to Mary, we see the fulfillment of all those promises—promises that involved Sarah, Hagar, Rebekah, Rachel, Leah, Tamar, Miriam, Rahab, Deborah, Naomi, Ruth, Hannah, Abigail, Bathsheba, Huldah, Esther, and Elizabeth.

> **READ LUKE 1:46-55, PRINTED ON THE NEXT PAGE.** Read it slowly and reflectively, and out loud if you're able. As you read, highlight everything Mary praises about God. Circle everything she says about herself.

These verses, known as the Magnificat for "magnifies," form a statement of praise from Mary to God for His faithfulness to His people. Mary is a true example of one devoted and faithful to the call of God and the walk of obedience until the end. Mary walked in the authority of the One who called her. She's also an example for us of God's faithfulness and love.

The final time Mary is mentioned in the Bible is a beautiful moment to end with today. After Jesus's resurrection, He remained on earth and with His disciples for forty days until He ascended to heaven, and He used that time to teach, encourage, and empower His disciples to continue. In Acts 1:14, we read of that time, "They all were continually united in prayer, along with the women, including Mary the mother of Jesus . . ." (Acts 1:14). Imagine the look on Mary's face as she saw prophecy fulfilled and her Son in all of His glory. Let us all be thankful to Mary, who delivered and brought forth the Child of promise that sealed our salvation, and who gives us a picture of devotion to inspire our own faith in Him.

Mary's example is one of faithful obedience to God and belief in His promises and plans. What does that look like for you today? How are you impacted by Mary's example from Scripture?

The Magnificat

46 And Mary said: My soul magnifies the Lord,

47 and my spirit rejoices in God my Savior,

48 because he has looked with favor on the humble condition of his servant. Surely, from now on all generations will call me blessed,

49 because the Mighty One has done great things for me, and his name is holy.

50 His mercy is from generation to generation on those who fear him.

51 He has done a mighty deed with his arm; he has scattered the proud because of the thoughts of their hearts;

52 he has toppled the mighty from their thrones and exalted the lowly.

53 He has satisfied the hungry with good things and sent the rich away empty.

54 He has helped his servant Israel, remembering his mercy

55 to Abraham and his descendants forever, just as he spoke to our ancestors.

LUKE 1:46-55

DAY 03

Anna

THE WORSHIPFUL HEART

By Julia B. Higgins

Anna's story is found in Luke 2:36-38. She is best known
for being a prophetess who met the Christ child
in the temple.

In the late 1870s, Louisa and William Stead took their daughter, Lily, on a trip to Long Island Sound, New York, for a family picnic at the beach. What should have been a joyful day turned into a mournful journey for Louisa. For you see, on that sunny day at the beach, Louisa's husband, William, witnessed a young boy drowning in the ocean. Seeking to rescue the child, William was pulled into the water himself. Louisa and Lily stood by as William drowned.[7] From the pain of losing a husband, Louisa came to know deeply the love of Jesus and penned the words to the famous hymn, "'Tis So Sweet to Trust in Jesus."

> Jesus, Jesus, how I trust Him! How I've proved Him o'er and o'er.
> Jesus, Jesus, precious Jesus! Oh, for grace to trust Him more![8]

Being a widow for a time, before remarrying, Louisa served in South Africa, devoting herself to the Great Commission (Matt. 28:19-20).[9] Today we are going to consider another widow with that same type of devotion—Anna. The story of Anna is found in Luke 2.

> READ LUKE 2:25-37 for the context for Anna's story.
> What do you learn about Anna in verses 36-37?

Joseph and Mary had come to the temple to obey the law, which required that a firstborn son be dedicated to the Lord and that atonement be made for a woman's uncleanness after having a baby (Luke 2:22-24). Following Jesus's dedication to the Lord, Luke introduces us to an eyewitness named Simeon, who uttered prophesies about Jesus in verses 25-35. Then, in verses 36-38, we meet Anna, another eyewitness at the temple. Notice Anna's devotion to God as a widow, in her worship, and through her witness.

Lots of pictures of Anna are found in verse 36. She is described as a prophetess, and her father's name and her tribe are provided. Yet none of those descriptors hit the heart like the one found in verses 36-37. Anna's husband died after seven short years of marriage, and then she lived the rest of her life on earth as a widow. Living as a widow during the first century meant a woman might find herself in poverty, yet a quick online search for the word *widow* in the Old Testament reminds us of

God's care for widows. In Psalm 68:5, David wrote, "God in his holy dwelling is a . . . champion of widows." God truly cares for the woman left alone.

> What, if any, unexpected or difficult circumstances do you find yourself in today? Is there a verse that reminds you of God's care, protection, and provision for you? If nothing comes to mind, look for one this week.

> READ LUKE 2:37 AGAIN. What insight does Luke give us into Anna's spiritual life?

Anna was an unexpected widow, but she also was an expectant worshiper. Verse 37 implies Anna spent her days in the court of women of the Jewish temple, praying and fasting faithfully.[10] This reflects humility and seeking God's favor and rescue, which communicates repentance. Anna sought God intently as He was at work in preparing His people.

> READ PSALM 69:10-18; EZRA 8:21-23; AND JOEL 2:12-14. What was the purpose of prayer and fasting in the manner we see Anna doing in this text? Do you notice any hints in the text that point to what Anna might have been praying and fasting about?

Consider all that is culminating when Luke's gospel begins. Throughout the Old Testament, Israel had received several promises from the Lord: a coming Messiah who would crush the head of the serpent (Gen. 3:15), the arrival of a Prophet greater than Moses (Deut. 18:15), a true and better High Priest to come (1 Sam. 2:35), a King who would reign on David's throne forever (2 Sam. 7:12-13), and a Suffering Servant who

would become an atoning sacrifice (Isa. 53). Because of these promises, Simeon was at the temple, "looking forward to Israel's consolation" (Luke 2:25) along with others who were "looking forward to the redemption of Jerusalem" (Luke 2:38).[11]

READ LUKE 2:38. How did Anna respond to the presentation of Jesus in the temple?

The story of Anna culminates in a proclamation about the Lord Jesus Christ. Earlier, in verse 36, Anna was introduced as a "prophetess." Having been at the temple day and night waiting for the coming Messiah, she heard Simeon's prayer and his words to Joseph and Mary concerning Jesus in verses 29-34. Anna's response was to bless God in thanksgiving (v. 38). In this moment, Anna was prophesying. Remember, this event was taking place in the court of women. That was the location in the temple where men and women alike worshiped, and it had room for approximately six thousand people.[12] We have to wonder how many people heard Anna as she connected Jesus to the longing for redemption expressed in verse 38. The prayers and hopes of Israel were answered in the baby born in Bethlehem, now being presented at the temple. (When you have a few extra minutes, read Gen. 3:15; Deut. 18:15; 1 Sam. 2:35; 2 Sam. 7:12-13; and Isa. 53 for a glimpse at the promises fulfilled in Jesus.)

After the unexpected circumstances of life, Anna was an expectant worshiper of God who earnestly witnessed about Jesus—the One who would offer His life, not just for Israel but for all. If you have realized through reading about the life of Anna that you have not been redeemed by the blood of Jesus, call out to Him today, and read the message to you on page 164. If you belong to Christ, remember His great care for you as a woman and how He has called and equipped you to serve Him through your worship and your witness.

READ JOEL 2:28-29 AND ACTS 2:17-18. How has God equipped you to proclaim the gospel and build up others? In what ways can you, like Anna, devote yourself to the worship and service of God, particularly through the local church?

Joanna

THE SERVANT HEART

By Laynie Travis

Joanna's story is found in Luke 8:1-3 and Luke 24:1-11. She is best known for being a disciple of Jesus and supporting His earthly ministry.

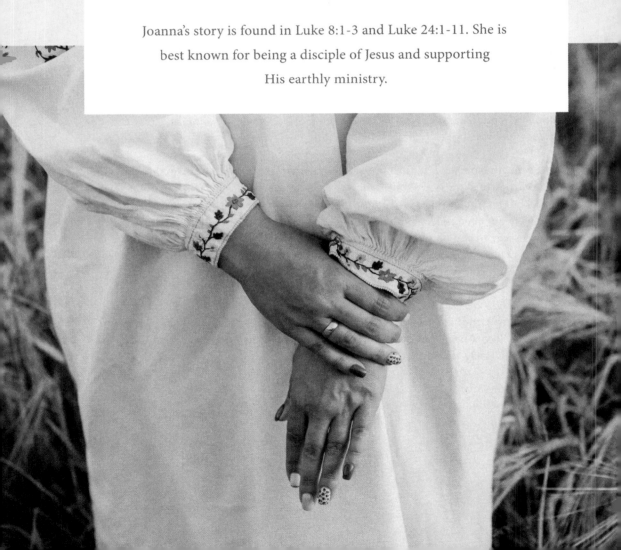

While sitting on the sidelines of my daughter Sloane's soccer game and chatting with other moms, I noticed security guards on both ends of the field. I inquired about the guards, and I learned that the governor's wife was in attendance. Her daughter was playing, and security followed her family wherever they went. I scanned the crowd and spotted her sitting across the field cheering for her daughter. I had never met her, but just by knowing whom she was married to, I felt that I knew something about her life. She was a woman of high profile and someone connected to the world of politics. I instantly had respect for her and her position.

This same principle rings true for a woman in the Bible who is introduced as "Joanna, wife of Chuza." Joanna was a Jewish woman who is mentioned by name in only two verses in Scripture, but we discover much about her world just by understanding who her husband was.

> READ LUKE 8:1-3. What do you learn about Joanna and her connection to Jesus from these three verses?

Luke tells us that Joanna was among the women who experienced Jesus's healing power. We also learn that she was wife of a man named Chuza. Chuza was Herod's steward, meaning he managed and oversaw the properties and finances of Herod Antipas, son of Herod the Great, who ruled as tetrarch of the Galilean territory from 4 BC–AD 39 in the time of Jesus.[13] Chuza's title was a prominent one. It is said of his position that "there could be no more trusted and important official."[14] As his wife, Joanna would have been immersed in the political realm of the Roman Empire and well-known among the Roman and Jewish people. Like the governor's wife here in my home state, she lived in the public eye. She would not have gone unnoticed in a crowd. She was a woman associated with power, wealth, and status.

What is interesting about Joanna's story is that this woman of social standing was also a faithful follower of Jesus. This was an unusual combination in that time. First-century Judaism had strict social divisions in place. Women in the Jewish world, especially those who were married and ran in Roman political circles, were not permitted to follow a rabbi.[15]

In these few sentences in Luke regarding Joanna and Jesus, we see a clash of cultures between the Roman and the Jewish world, a clash of company between Joanna (the wife of Chuza) and Mary Magdalene (the outcast who had seven demons), and a clash of social standing with the upper class mingling among the impoverished.

READ GALATIANS 3:28; COLOSSIANS 3:11; AND ROMANS 2:11. What is the running theme? What are some barriers that separate people groups today?

Time and again in the Gospels, Jesus broke through social barriers and welcomed everyone into His presence. Joanna was no exception. Jesus calls all people to Him, no matter their background, social standing, profession, health, political views, past, or present circumstances. Jesus consistently invites people from every crowd and sphere of influence into relationship. He was intentional in His pursuit of Joanna. He is intentional in His pursuit of you. So, how did Joanna come to know Jesus?

READ MARK 6:7-20. What clues does this passage have for how Joanna may have come to know Jesus?

Joanna lived immersed in Herod's palace life and would most assuredly have heard talk of Jesus. "Herod's main residence was in Galilee, not far from Nazareth, where Jesus grew up."[16] The name of Jesus was becoming well-known all through this region. Mark tells us that John the Baptist often preached about Jesus in King Herod's courts, and though his preaching "perplexed" the king, Herod liked to listen to him. Chuza would have been well-versed in the activity that went on in the king's courts, and we can assume that Joanna had heard John the Baptist preaching about Jesus either directly or indirectly.

Prior to meeting Jesus, we know that Joanna was suffering from an affliction. I can imagine her, in her desperation, going to find Jesus—the Healer and the holy Man that she had heard so much about.

LOOK BACK AT LUKE 8:3. After being healed by Jesus, what did Joanna do?

When Joanna met Christ, He not only healed her; He transformed her spiritually. She then devoted her life to serving Jesus and supporting Him out of her own means. In this patriarchal society, women were dependent on men for provision. However, Jesus humbly relied on her and other women (and probably men) for provision to further His ministry.[17] This was a way Joanna could serve Christ, and He honored her service.

NOW READ LUKE 23:44-55 AND LUKE 24:1-11. In what ways did Joanna express unconditional devotion to Jesus?

Joanna was among the women who went to Jesus's tomb to dress His crucified body. She didn't know how the story would end, but she chose to serve faithfully despite her confusion and her grief. Joanna was also among the first women to learn the news of Jesus's resurrection. She then shared the news of the risen Lord with the disciples. Jesus gave her a new mission and rewarded her devotion.

How does Joanna's example of devotion to Jesus motivate you in your faith? What are some ways you can serve Jesus using the resources God has given you?

Joanna was drawn to Christ. He called her. Jesus is calling you, too—right where you are. Jesus knows your name, He knows your story, and He knows the world you live in. He wants you to come to Him as you are. Jesus wants to reveal His power to you and show you how to be an influencer for His kingdom. Today, whatever your life circumstances, rest in these truths: Jesus is pursuing you. He created you to live out your unique calling. You have an opportunity to serve Jesus with your resources and reveal His power in your sphere of influence.

DAY 05

A Bleeding Woman

THE DESPERATE HEART

By Kristin L. Kellen

The story of the woman with the bleeding condition is found in Mark 5:25-34. She is best known for touching the hem of Jesus's garment in faith so that He could heal her. She is never given a name, but she is also mentioned in Matthew 9:20-22 and Luke 8:43-48.

We've all gone through seasons of suffering in our lives, and as we've seen in our study, suffering has touched the life of every woman we've studied in the Bible so far. It's an unavoidable aspect of life this side of heaven. Today we turn to the account of the bleeding woman in Mark 5, a woman who had suffered tremendously for more than a decade.

This story is a beautiful picture of immediate restoration and healing, but it also points us forward to the healing that we will one day experience through Christ. As we study this woman's story and its inclusion in God's Word, we are reminded that our faith matters; it can accomplish miraculous things.

READ MARK 5:25-34. Write down one word that comes to mind as you read this woman's story.

Prior to her encounter with Jesus, what had the woman done to alleviate her suffering? What sort of impact did that have on her quality of life?

In this passage, we're introduced to a woman who had undergone great suffering; she had been bleeding for twelve years, but the cause of her bleeding remains unclear from the details in the text. What we can assume is that not only did her bleeding cause physical pain, but because of Old Testament laws, it would have also kept her from coming into the temple to worship. It was a barrier for her to fully be a part of Jewish society (Lev. 15:25-31).

As we see at the end of verse 26, the bleeding woman had done just about everything she knew to do to alleviate her condition. She spent all her resources, visited the doctors, and endured what had to have been painful procedures in search of a cure. But, as the Scriptures tell us, none of it helped. In fact, they made her more sick. As we might imagine, this woman was likely at the end of her rope; she had tried everything. Everything except what would ultimately heal her.

REREAD MARK 5:27-29. What do you think drove this woman to seek out Jesus?

In these few verses, we see something miraculous happen. The woman made her way through a large crowd to get to Jesus and simply touched the edge of His robe. No doubt, this woman had heard about the miracles that Jesus had done up until this point. Between the four New Testament Gospels—Matthew, Mark, Luke, and John—we see that Jesus had healed many people, driven out demons, and taught extensively to the people. He had gained quite a following, which is why there was a crowd around Him. Among the many things this woman felt, desperation was clearly one of them, and it drove her to the feet of the Healer. Sometimes we find ourselves in a similar position; we don't know where else to turn, but we, like this bleeding woman, know Jesus is worthy of our faith. Let's see how Jesus responded to her.

READ MARK 5:30-34. What stands out to you about Jesus's response? Why do you think Jesus asked the question "Who touched my clothes?" if He already knew the answer (v. 30)?

In this next section, we see Jesus's immediate response when He felt healing power leave His body. Because Jesus is God made flesh, all-knowing and all-powerful, He already knew who had touched Him and why. The disciples responded as we might if we were them, stating what was probably most obvious; but their perspective was limited. They didn't see what had happened; they didn't feel the instant healing that the bleeding woman had felt. Lucky to just graze the hem of Jesus's garment a moment earlier, now the woman's identity was revealed, and she fell at the feet of her Creator and Healer with "fear and trembling" (v. 32).

Write down one word that comes to mind as you read Jesus's response to the woman in verse 34.

READ EPHESIANS 1:3-6. Apply Paul's words to your own life if you are a follower of Christ. What does this mean about you? Why is it significant that God also calls you His daughter?

In verse 34, we read that Jesus called the woman "daughter." Jesus, the Son of God through whom all things were created and all things exist (Col. 1; Heb. 1), called into His family this woman whose disease had kept her from worshiping in the temple. He also expressed deep care and compassion for her, as *daughter* is a term of affection. But just as importantly, Jesus was conveying oneness with the Father. He and the Father are one; this is why He can call her "daughter." In this moment, she may or may not have caught the significance of that word, but looking back, we can. Like other places in the Gospels, this one word expressed Jesus's deity, not just His ability to heal.

Jesus's response points out that it is the bleeding woman's faith in Him that made her well. He ends this brief encounter telling her to "go in peace" and healing. Jesus met both her physical and spiritual needs, a distinct mark of His earthly ministry. He healed her body and sent her off with spiritual peace. She was reconciled to Him as His daughter and because of her faith, her body and her soul experienced restoration.

> As you think about suffering in your own life, how has Jesus healed you—spiritually, but also physically if that applies? This is your testimony, the story of Jesus's work in your life that you can use to tell others about Him!

As we reflect on this story, we see a woman of great faith who came before Jesus seeking healing. Her body was broken, but she was also separated from her God. By the end of this text, she was fully restored. In a similar way, we can seek out healing from our Great Physician. Like the bleeding woman, we can walk forward in faith and trust that Jesus will meet our every need. We might not experience immediate, miraculous healing like this bleeding woman, and we aren't guaranteed physical healing while in our broken bodies, but we can be saved and go in peace (v. 34). We can also rest knowing that ultimately, full restoration will come (Rev. 21:4).

If there is an area of your life where you are in need of physical, emotional, relational, or spiritual healing today, spend time now at the feet of Jesus in prayer. Remember that He calls you daughter.

REFLECT

Elizabeth, Mary Mother of Jesus, Anna, Joanna, a Bleeding Woman

Take a few minutes to reflect on the truths you uncovered in your study of God's Word this week.
Journal any final thoughts below, or use the space to take notes during your Bible study group conversation.
The three questions on the opposite page can be used for your personal reflection or group discussion.

Download the *Devoted* leader guide at lifeway.com/devoted

As you reflect on the Bible passages you read this week,
what stands out to you about the character of God?

How have you been challenged and encouraged in your relationship
with Jesus through the Scripture you studied?

Write down one way you can use what you've
learned this week to encourage someone else.

Week Five

MARY OF BETHANY · MARTHA · THE SAMARITAN WOMAN
MARY MAGDALENE · DORCAS

DAY 01

Mary of Bethany

AT THE FEET OF JESUS

By Erin Franklin

Mary's story is found in Luke 10:38-42; John 11:17-45; and John 12:1-8. She is best known for being sister to Martha and Lazarus and for sitting and learning at the feet of Jesus. Mary is also mentioned in Matthew 26:6-13 and Mark 14:3-9.

I have a friend in Tennessee who opened her church app one Sunday morning to double-check the schedule only to see listed at the bottom of the screen the location of the church: Colorado! The Colorado church has the same name and nearly identical logo and branding as her church in Tennessee, and she had simply downloaded the Colorado church's app since it popped up first in the search results on the app store. But it gets better. The whole reason she had the app was so she could set up her recurring tithe. My friend, who lives and goes to church in Tennessee, realized she had been tithing to the *wrong church* for six months! Although she felt a little foolish, she chose to believe God used her gift just as well in Colorado as He would have in Tennessee.

Today in our study, we're going to read about another gift that was initially deemed— from a human perspective—foolish. But first, let's get to know the gift-giver, Mary. One of three famous Marys in the New Testament, this one is identified both as Martha's sister and Mary of Bethany. She is sometimes confused with Mary Magdalene, whom you will study next week, but church tradition identifies them as two different women. We will learn about Mary of Bethany in Luke 10.

READ LUKE 10:38-42. Write down everything you learn about Mary in this scene.

Whose choice did Jesus celebrate? Why do you think He did this when the Bible also teaches hospitality and service to others?

Although Scripture doesn't explicitly note the birth order of Mary and Martha, several commentators suggest Martha was the older sister since she served as hostess.[1] Martha became frustrated with Mary's apparent lack of effort in busying herself to help. She was "worried and upset about many things" (v. 41), but Jesus commended Mary's humble, focused attitude toward Him.

It's interesting that Scripture tells us Mary sat at her Lord's feet (v. 39) because rabbis would often sit on low pillars or chairs while they taught, with their disciples sitting on the ground or on mats as they listened to their teacher. As Ann Spangler and Lois Tverberg note in their book, *Sitting at the Feet of Rabbi Jesus*, "That's how the phrase 'sit at his feet' became an idiom for learning from a rabbi."[2] This was not a common

position for a woman to be in during Jesus's day, but Luke made sure we see Mary for who she was—a disciple devoted to learning from her Teacher.

The two sisters have often been pitted against each other for their different choices in the presence of Jesus. While Mary did make the "right" choice here, Jesus didn't condemn Martha's generosity and service; rather, He corrected her attitude, seeking to refocus her attention. He wanted her to understand that a heart truly devoted to Him is rooted in a personal relationship with Him. Mary made the correct choice because she recognized the privilege of being in the presence of Jesus and refused to be distracted by anything else.

What does it look like to make "the right choice" (v. 42) by posturing yourself at the feet of Jesus today?

NOW READ ALL OF JOHN 11, the next time we hear about Mary. Who sent for Jesus? Why did Jesus wait to come?

When Jesus arrived, how were Martha's and Mary's responses to being in His presence different from each other, and how were they similar?

Different	Similar

When Mary heard Jesus calling for her after her brother Lazarus died, she "quickly" (v. 29) went to Him. As soon as she came into His presence, Mary was again at Jesus's feet, this time falling in distress with a broken cry. One commentator notes that "those who, in a day of peace, set themselves at Christ's feet to be taught by him, may with

comfort, in a day of trouble, cast themselves at his feet, to find favour with him."[3] Mary recognized Christ as both Lord and friend (v. 27).

John 11 gives a beautiful picture of Jesus's divinity and humanity in action. The miracle of raising Lazarus from the dead is so utterly incredible that there is no question He is Lord. But right before this, the deep emotions of love and grief causing Him to weep are so familiar to us—as humans living in a broken world—that there is no question of His humanity. As Mary grieved, He shared her pain.

NOW READ JOHN 12:1-8. Where is Mary in this scene?

How incredible it is that in all three accounts Mary is seen at the feet of Jesus! First, she sat at His feet to learn. Then, she fell at His feet to lament her brother's death. Now, she humbly washes His feet with her hair, anointing Him with a lavish gift. Mary worshiped her Teacher—expressing her gratitude and love for Him with a gift so great it cost a year's wages.

Why did Judas say Mary's gift was foolish? What does Jesus's response to Judas say about our priorities?

Judas indignantly questioned Mary's act of devotion. Jesus immediately rebuked Judas, protecting Mary and clearly stating her act was justified because this was His burial anointing. John 12 begins the most important week in all of Scripture—culminating with the fulfillment of God's mission to bring salvation through Christ's death and resurrection—so it's fitting the week opens with Mary's humble anointing of Jesus as her King.

What do you learn from Mary's example about how to be a woman devoted to Jesus and God's mission? Sum up your thoughts in a few words.

Mary provides the model picture of the posture Christians must seek to hold—surrender at the feet of Jesus. He invites everyone into His presence to listen, lament, and express our love at the feet of our Teacher.

DAY 02

Martha

FAITH AND ACTION

By Terri Stovall

Martha's story is found in Luke 10:38-42 and John 11:1-44. She is best known for showing hospitality to Jesus and His disciples and for believing Jesus was the Messiah. Martha is also mentioned in John 12:2.

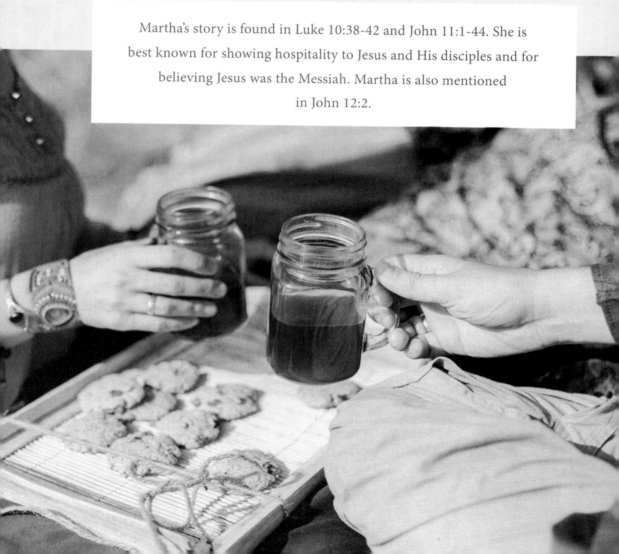

I am a Martha. There, I said it. Many of us wish to be the Mary we learned about in the previous day's study, the disciple who balances service and worship so well. But more often than not we find ourselves going through our days as Martha. Believed to be the eldest sibling of Mary, Martha often is portrayed as the example of who not to be. However, if you look at the snapshots of her life provided in Scripture, you start to see a different person emerge. Martha is mentioned in three specific stories in the New Testament (the same stories as her sister) that give us a wonderful picture of her devotion to Jesus. Martha was a true servant and a woman of confident faith.

READ LUKE 10:38-42. Write down everything you learn about Martha in this scene. Specifically, how does the text describe Martha's mood in verses 40 and 41?

Our first glimpse of Martha is as the hostess of the home. Most Bible scholars believe that since Martha was likely the eldest sister of Mary and Lazarus, they lived with her, and the home they lived in was considered her house. We don't know if she was widowed or why the three siblings lived together, but as we read about Martha, it is clear that she was the one who cared for and took charge of the family.

The word *distracted* (v. 40) comes from a Greek word that means being overburdened or drawn away by various things to the point of becoming worried and anxious. The problem here was not that Martha was busy doing all the hospitality tasks that needed to be done, but that she allowed all the tasks to pull her eyes away from Jesus and to focus on herself. I know I've been there, and I'm sure you can fill in those blanks with moments from your own life and see how quickly our gaze turns inward on ourselves.

What commonly distracts you or draws your focus away from Christ? List the things that come to mind.

READ VERSE 40 AGAIN. Martha asked Jesus, "Don't you care?" While Scripture doesn't give us all the details, I can imagine the room grew instantly quiet and all eyes turned to Martha, surprised by her outburst. But Jesus gave her a gentle, tender rebuke in His loving way. Speaking her name twice, Jesus refocused her attention on Him

and reminded her of what was most important. Martha was a servant and a doer but needed to be reminded of who and why she served.

> NOW READ JOHN 11:1-44, the next time we see Martha. As you read, make notes of what Martha did and said.

The relationship between Jesus and this family was a close, intimate relationship. From Scripture we can conclude they were some of His closest friends. Martha, Mary, and Lazarus loved Jesus, and "Jesus loved Martha, her sister, and Lazarus" (v. 5). When Lazarus fell ill, his sisters sent word to Jesus. The timeline and travel distance indicate Lazarus died soon after the messenger left to tell Jesus. Martha had been grieving the loss of her brother for several days before Jesus finally arrived in Bethany, but still she rushed out to meet Him.

> READ VERSES 21 AND 22 AGAIN. What do these verses communicate about Martha's relationship with Jesus? About what she believed He was capable of?

Martha's greeting here is not a tone of frustration as we read in the Luke 10 passage, but came from a heart of grief and faith. She had spent enough time with Jesus to see Him heal people, so she knew that if He had been there before Lazarus died, He could have done the same for her brother. As Jesus and Martha continued to talk, we find two significant statements of declaration. One from Jesus and one from Martha.

> In verse 25, how did Jesus describe Himself?

Jesus's declaration, "I am the resurrection and the life," is one of seven "I am" statements found in the Gospel of John. (For the others, see John 6:35; John 8:12; John 10:7; John 10:11; John 14:6; and John 15:1.) Each statement—a self-declaration of Jesus's deity—requires a response from the hearer.

In verse 27, what did Martha declare in response?

Martha's declaration was not a half-hearted statement. The grammatical structure found here gave her declaration an emphatic force, fervently proclaiming her belief in Jesus as the Messiah, a settled conviction that could not be shaken. Martha clung to the anticipation that she would see Lazarus again someday; she grieved with hope. When she walked away to get Mary, she left still hopeful, still confident in Jesus, her faith still intact, and also thinking that her brother was still dead. Little did she know that same day was going to be Lazarus's resurrection day.

READ JOHN 12:1-3. What does verse 2 say about Martha?

The scene looks similar to the scene in the Luke 10 passage we examined. We again see Mary at the feet of Jesus and Martha serving the people. Both were worshiping Jesus in their own way, this time seemingly without complaint. Martha was not distracted by many things, but doing many things focused on one—her Messiah.

Martha was a valued servant and a woman of confident faith. We need women like her in our homes, churches, and communities. Through a ministry of service and hospitality, a woman like Martha can be the hands and feet of Jesus to a world that needs hope. And like Martha of the New Testament, many of us need to be reminded not to allow the world's distractions to take our eyes off Jesus but to declare our faith in Him with confidence.

How do you explain to others the hope you have in a world that can also bring disappointment, trials, and grief?

Take some time now with the Lord in prayer, confessing what has drawn you from Him. Speak out loud your personal declaration of faith in Him.

WEEK FIVE

The Samaritan Woman

A LIVING TESTIMONY

By Christina Zimmerman

The Samaritan woman's story is found in John 4:1-42. She is best known for her very personal conversation with Jesus and for telling other people in the town about her encounter with the Messiah. Her name is unknown, and she is not mentioned again in Scripture.

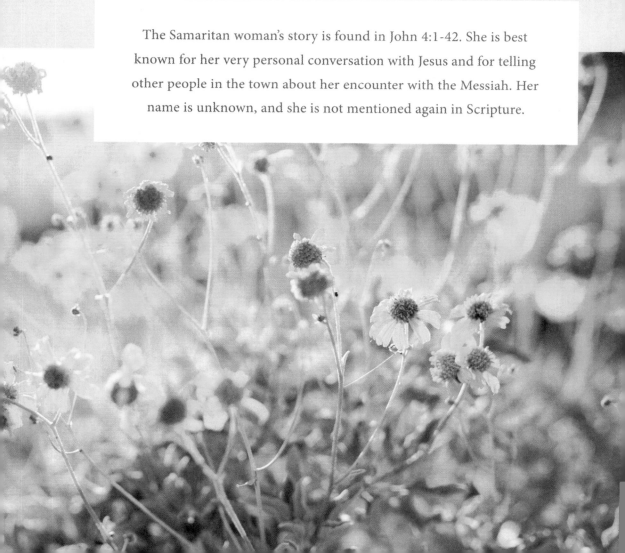

Familiar Bible stories have the potential for taking us deeper in our understanding of God's truths. But this often means we have to be intentional about reading them with fresh eyes and the expectation of receiving something more. If you've been a follower of Jesus for some time now, then the story of the Samaritan woman is likely one of those familiar stories. Let's see what insights God has for us from the story about Jesus's encounter with the woman at the well.

> READ JOHN 4:1-9. Note what you learn about the woman from the opening verses of her story. What surprised the woman about her initial interaction with Jesus? Do these things surprise you as you read the story? Why or why not?

On His journey to Galilee, Jesus ventured through Samaria, where He met a Samaritan woman. It's difficult for us to understand just how unconventional Jesus's trek through Samaria would have been (v. 4). Jewish rabbis considered Samaritans to be in a continual state of uncleanness. The Jews detested the mixed marriages and idol worship of their northern cousins. The animosity was so great that Jews would bypass Samaria as they traveled between Galilee and Judea, going an extra distance through barren land to avoid passing through Samaria.

Jesus, however, did not fear being defiled. His compassion toward people superseded prejudice. Even more so, Jesus told Nicodemus that His Father loved everyone in the world (John 3:16). It would have also surprised the woman that Jesus talked to her simply because she was a woman and she was alone. This shouldn't surprise the Gospel reader, though. Jesus's compassion toward women was highlighted as He repeatedly interacted with them during a time when women were placed in a lower class than men.

> NOW READ JOHN 4:10-18. What additional information do you learn about the woman from these verses? What does Jesus reveal about Himself in their conversation?

Jesus's request for a drink of water (v. 7) and the woman's response (v. 9) led to a lengthy conversation. She did not ask Jesus for anything, but He offered her everything. He acknowledged that she did not know who He was, but He said if she knew that He was the Giver of life, she would ask for "living water" (v. 10). The woman had no idea what Jesus was talking about. The only thing she knew for certain at this point was that He was a Jew.

List the questions the Samaritan woman had asked Jesus up to this point in their conversation.

VERSE 9

VERSE 11

VERSE 12

The woman wanted answers to pointed questions and thoughts. In verse 13, Jesus responded to her questions with mercy and with blessing. He offered her living water for her dry and sin-sick soul. This concept of living water is a theme in John's Gospel, and Jesus defined it explicitly in John 7. He said, "The one who believes in me, as the Scripture has said, will have streams of living water flow from deep within him" (v. 38). Jesus offered this woman the gift of eternal life and the presence of His Spirit.

As their conversation continued, Jesus opened the woman's eyes to His divine nature by revealing just how much He already knew about her (vv. 15-17). The woman's despair, her brokenness, and her deep need for salvation were exposed. Jesus first connected with her, then He offered her eternal life, and then He made a pathway for her to deal with her sin.

READ JOHN 4:19-42. As you read, keep a list of what Jesus revealed about Himself and how the woman responded to Him.

What Jesus Revealed	How the Woman Responded

The Samaritan woman no longer saw Jesus as a peculiar person acting against the norm, but as a prophet to whom God had revealed things about her. Slowly the woman's heart was being transformed and her soul was bowing down. Verse 20 reveals she wanted to be right with God and believed this was a matter of worship, but she didn't know where to go. Should she worship where she was, or should she go to Jerusalem?

In verse 24, Jesus reminded the woman of the nature of God. He said, "God is spirit," which means God cannot be contained in one place. God is everywhere, not just on a mountain or in Jerusalem. Therefore, God can be worshiped anywhere. In essence, Jesus told her to stay right where she was. He revealed that all she needed to worship was a heart that loves God.

But how do you get a heart that loves God? Through the living water of Jesus's Holy Spirit. When Jesus pours out His living water—His Spirit—into our hearts, we find ourselves with a heart that loves and worships Him in Spirit and in truth. Here Jesus brought together everything He discussed with the woman, which culminates in verse 26: "Jesus told her, 'I, the one speaking to you, am he.'" Jesus revealed Himself to her as the Messiah. With the hope and joy of salvation, she forgot about everything, including the water, and she ran back to the town to tell everyone about Jesus. Because of the testimony of this woman many people in Sychar, Samaria, were saved and came to know Christ.

Before you finish your study for today, take a few minutes to reflect on the change Jesus has brought to your life. First, spend time in prayer, thanking God for drawing you to Himself. Then, in a journal or note on your phone, write down some names of people whom you need to tell about the love and joy found in Jesus and some ideas for how you can start those conversations in the coming days.

Mary Magdalene

FOLLOWING TO THE END

By Ashley Marivittori Gorman

Mary Magdalene's story is told in Matthew 27–28; Mark 15–16; and John 20. She is best known for being the first person to see Jesus after His resurrection. Mary Magdalene is also mentioned in Luke 8:2; Luke 24:10; and John 19:25.

One summer, my aunt took my cousin Sara (4) and me (8) to a pool in the backyard of her friend Jenny's house. I was tasked to keep Sara in the shallow end until the adults got in the pool, but as I circled her around the pool, I didn't realize my steps were drifting toward the deep end. Eventually, the pool's floor descended lower than I could reach, and I lost not only my footing, but the ability to hold up Sara's head. Once we were both completely submerged and flailing under water, our survival instincts kicked in, and we each tried to push the other down in order to climb up for air. Suddenly, I sensed the boom of someone plunging into the water and then, finally, I felt strong arms behind me, raising me up to the pool side. Jenny had jumped in and rescued us both.

In the months and years following this ordeal, I was jolted into a new outlook on life, acutely grateful for things I usually complained about and suddenly serious about using my time in ways that mattered. As I look back on the memory, I realize that while I was certainly grateful to be saved *from* the waters of death, what took up most of my attention moving forward was what I was saved *to*—new life. Severe or trivial, we all carry memories of being saved from something bad to something good. As it turns out, Mary Magdalene can relate.

> **READ MARK 16:9 AND LUKE 8:1-3.** What sort of spiritual history did Mary Magdalene have before she encountered Jesus?

Not to be confused with Mary the mother of Jesus, Mary of Bethany, or the sinful woman of Luke 7:37, Mary Magdalene is identified by her hometown—the city of Magdala (or Magadan) on the western side of Galilee. Scripture gives us a starting place for her spiritual journey by briefly filling us in on her backstory. She is famously remembered as the Mary who was possessed by not just one but seven demons. The number seven is significant here, as it is one way the Bible conveys a sense of totality or completion—this contingent of demons had taken up total residence in Mary. Consumed and flailing under their influence, she was not just disturbed in her internal world but was a social outcast of the lowest order in her external world too.[4] If we are curious about what Jesus saved Mary Magdalene from, it was not only a life totally submerged by demonic domination but public shame as well.

Interestingly, the Bible doesn't focus much on this miraculous moment; instead, Scripture spills far more ink on what Mary is known for *after* she was freed: following Jesus faithfully. The lion's share of Mary's story teaches us not what it means to simply

be saved *from* the grasp of sin, death, and evil (important as that is), but saved *to* new life in Christ—to a life of followership. As we follow Mary's footsteps post-conversion, we will find her close on the heels of her Teacher, showing us what this new life in Christ actually looks like.

> Read the following verses in your Bible and (circle) the action verbs or write them below: Matthew 27:55-56; Mark 15:40-41; Luke 8:1-2.

Among the action verbs in the verses you just looked at are the words *followed* and *took care of.* (I'm using the CSB translation of the Bible.) *Followed* is a term used for pupils of a rabbi, meaning "walking the same road" or "being in the same way with."[5] Mary wasn't a mere spectator or fan of Jesus. After her conversion, she took the posture of a disciple, conforming to the ways of her teacher.

Followership to Jesus means not only experiencing a moment of freedom from past darkness, nor adopting an assortment of His teachings as you go your own way, but quite literally following Him wherever He says to go from conversion onward. It means wholly conforming to His teaching and embodying His character from wherever your "Galilee" is. Mary Magdalene followed Him there and beyond, for He had driven out her darkness with His great light and restored her to honor in the places she had only known shame.

> Do you have a version of "Galilee" in your life? What would help you follow Jesus faithfully and confidently in that place?

Along with other women, Mary Magdalene not only walked like Jesus, she served Him and attended to whatever His quest required.[6] Mary did not merely receive Jesus's great work in her own life and then call it a day; she was part of extending that same work to others as she served Jesus in His mission to those beyond her. New life in Christ means not just receiving the benefits of Jesus's mission to rescue us, but serving up whatever resources we can to extend those benefits to others. To follow Jesus means being close enough to His work that we can clearly sense the ways we might specifically contribute to it.

What specific resources have you been blessed with that you could contribute to the mission of Jesus? (Think about specific spiritual gifts, particular blocks of time, a certain amount of money, a specific expertise, certain possessions, etc.)

NOW READ MATTHEW 27:45-56; MARK 15:33-41; AND JOHN 19:25. In this scene, Mary is publicly associated with Jesus by three of the Gospel writers. Why do you think this association, especially at the cross, is important? How does this challenge you? Encourage you?

Next, we see that when the going got tough, Mary still followed Jesus all the way to the horrors of the cross, standing right beside it as the Savior willingly drank the cup of wrath for human sin, all while many of His other disciples ran and hid (Matt. 26:31,56; John 16:32). Here Mary teaches us that being saved to new life in Christ means publicly standing with Him in His death, demonstrating that we are united to Him in all He does and that we take on a cross-shaped life (Gal. 2:20).

Read the following Gospel accounts of what took place after the crucifixion, focusing on Mary's presence: MATTHEW 27:57-61; MATTHEW 28:1-10; MARK 15:47; LUKE 24:1-12; AND JOHN 20:1-18.

What stands out to you about Mary's actions in the days and moments after Jesus died? Why is the part Mary played in the resurrection account so important?

When Jesus finally died and we'd expect Mary to run away in anguish, we find that she followed Jesus again, this time to His tomb. Even in her deepest grief, even when she thought all hope was lost, even when she wept in agony over her Lord's death, we find Mary graveside, still drawing near to wherever Jesus was. Then later seeking to anoint His body with oil (a customary practice in her day), Mary unknowingly followed Jesus to His resurrection, where He called her by name to reveal He had risen (Mark 16:9; John 20:16).

As if all this wasn't enough, Mary was also the first of Jesus's followers charged to share the good news of His resurrection (John 20:17). In a day when a woman's word wasn't even considered trustworthy in court, this is no small detail. Who could have imagined that Jesus would call a woman with such dark beginnings to be the first evangelist to declare the Light of the world had risen? The last we see of Mary, she was proving herself a faithful follower of Jesus yet again, obeying His command to share the good news with His disciples (John 20:18).

What a story! All these parts of her journey taken together, Mary's example of followership to Jesus clearly instructs us what it looks like to be united to Christ in His life, death, burial, resurrection, and mission. She teaches us that Christ Himself plunged into the waters of not just our dark yesterdays, but death itself, pulling us up from the deep to walk in a new life to which we are saved (Rom. 6). May we, like Mary, keep following Jesus with each of our todays no matter where He leads, keep proclaiming His message no matter how it's received, and keep looking forward to the great and sure glory of a resurrected tomorrow when our faith becomes sight.

Of all you learned from Mary's story, which part of following Jesus seems to be most natural for you? Which part of following Him is hardest for you? In what ways can you celebrate your strengths and develop your weaknesses?

To follow Jesus
means being close
enough to His work
that we can clearly
sense the ways we
might specifically

contribute

to it.

Dorcas

LOVE IN ACTION

By Tessa Morrell

Dorcas's story is found in Acts 9:36-43. Also called Tabitha, she is not mentioned in any other parts of the Bible. Dorcas is best known for her kindness and generosity and for being raised from the dead by Peter.

Imagine for a moment that you've lost your husband, and there is no one else in your life. You live in a society that is built around all provision and protection being provided by men only. You are now a vulnerable woman who is alone—not only grieving the loss of the one you love, but also facing an unknown future. How will you survive? Put food on the table? Have money for clothes, shelter, and other basic provisions? Now imagine a woman in your community reaches out and provides you with clothing, comfort, and kindness. She takes time to see you and your tangible needs, and she selflessly does all that she can to help you. It would make a world of difference, right?

In the book of Acts, we read the story of one such woman—a woman who saw and cared and acted—and her name was Dorcas. Unlike Mary Magdalene, whose story spans all four Gospels and much of Jesus's earthly ministry, Dorcas only shows up one time in Scripture, and it's very brief. But in just a few verses, we learn how her love for Jesus motivated her to love those around her who were often forgotten, unseen, and alone. We'll also see how witnessing a miracle led people around her to faith in Jesus. The life of Dorcas is a beautiful portrayal of what happens when a person utilizes her time and practical skills to meet tangible needs.

READ DORCAS'S STORY IN ACTS 9:36-43. Then reread verse 36. What details do you learn about Dorcas in this verse?

Much is revealed about Dorcas from just this one short verse. We see that she was a disciple of Jesus (notably the only time the feminine form of the Greek word translated *disciple* shows up in the New Testament),[7] and she lived in a place named Joppa. Her name was Tabitha, "which is translated Dorcas," and she was best known for "always doing good works and acts of charity" (v. 36).

We get the impression from this verse that Dorcas was motivated to meet the needs of others out of the overflow of her love for the Lord. Ephesians 2:8-10 tells us that we are saved by grace through faith. It is a gift of God. And it is because of that precious gift that we are motivated to do the good works God has created us to do. Dorcas embodied this with the way she loved others.

NOW LOOK AT ACTS 9:37-38 AGAIN. What stands out to you?

Right after introducing readers to Dorcas, the text tells us she became sick and died. These events happened while Peter was traveling and preaching about Jesus's death and resurrection. The people had heard Peter was in Lydda, which was near where they lived in Joppa. It's likely that the news of the healing of Aeneas (Acts 9:32-35) had made its way to Joppa, and the people wanted Peter's help. They even went so far as to prepare her body for healing. The faith of the people led them to go to Peter, a person whom they knew loved and served the Lord.

READ ACTS 9:39. What did the widows do when Peter arrived? What do you think motivated them to show him all that Dorcas had done for them? What does this teach you about Dorcas's character and influence?

Because of the widow's vulnerable place in society, the church was directed to be a source of support for them (1 Tim. 5:3-16), and Dorcas was a faithful example of how meaningful this support would have been for these women. Though they were at risk of being forgotten and overlooked, she saw them and met their needs. In their grief over her death, that's what they remembered her for.

READ ACTS 9:40-43. Compare Acts 9:40 with Mark 5:41. What is similar in these two accounts of someone being brought back to life? What is noticeably different?

The words Peter spoke over Dorcas's dead body remind readers of one of Jesus's miracles, when He brought Jairus's daughter back to life. This miracle was so profound that it became known throughout the town, and many people believed the Lord. God used the turning around of this tragic loss to bring people to faith in Him.

These eight verses in Acts contain so much that we can apply to our lives, beginning with the faithful example of Dorcas. She was a woman who served the people who were often uncared for and overlooked. The story of Dorcas also brings to mind the concept of legacy. Though it ended up that her story wasn't quite over yet, her death initially brought reflection about the life she lived. Dorcas was a selfless follower of Jesus who looked for opportunities to make a kingdom impact in her community.

> When you are gone, what do you hope people will remember most about you?

> What can you do in your daily life now that will bring glory to the Lord and serve others even after you're gone?

Who in your neighborhood, church, family, or community needs care and attention? Write down the name of at least one person. What is something you can do this week—or even today—to reach out and extend kindness and love to that person?

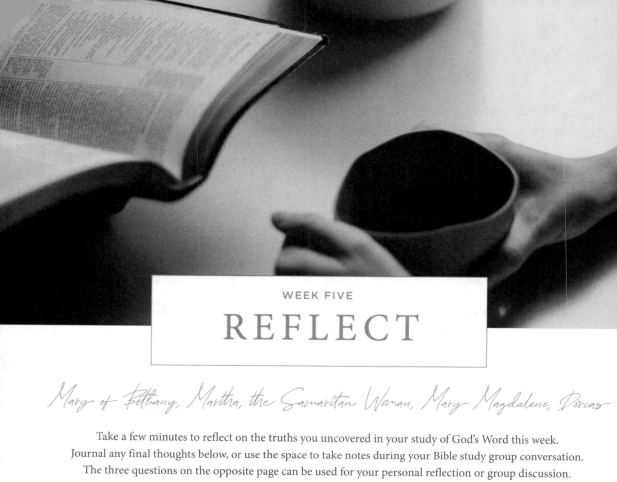

REFLECT

Mary of Bethany, Martha, the Samaritan Woman, Mary Magdalene, Dorcas

Take a few minutes to reflect on the truths you uncovered in your study of God's Word this week.
Journal any final thoughts below, or use the space to take notes during your Bible study group conversation.
The three questions on the opposite page can be used for your personal reflection or group discussion.

Download the *Devoted* leader guide at lifeway.com/devoted

As you reflect on the Bible passages you read this week, what stands out to you about the character of God?

How have you been challenged and encouraged in your relationship with Jesus through the Scripture you studied?

Write down one way you can use what you've learned this week to encourage someone else.

Week Six

LYDIA • PRISCILLA • PHOEBE
EUODIA & SYNTYCHE • LOIS & EUNICE

DAY 01

Lydia

A HEART TRANSFORMED

By Shelly D. Harris

Lydia's story is found in Acts 16:11-15. She is best known for being converted to faith in Jesus by the apostle Paul. Lydia is also mentioned in Acts 16:40.

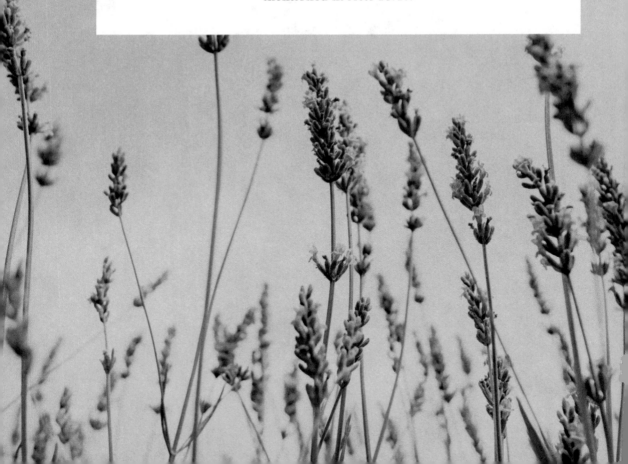

One of the joys I have in serving in kids ministry is having gospel conversations with boys and girls. Kids ask such a wide range of questions, from things like "Is God an alien?" to "How do I know if I am a Christian because I still sin?" Kids will keep you on your toes!

Most gospel conversations are simply planting seeds of the gospel, answering a question, or helping kids see a Bible truth in Scripture. But occasionally, I have the joy of talking with a child who is ready to repent of her sin and trust Jesus as her Savior and Lord. It's clear she is being called by the Savior to respond to the gospel. It's a holy moment to listen to a child pray, asking God for forgiveness of her sin and placing her full trust in Jesus as Savior and Lord.

As I read the story of Lydia in Acts, I found myself wondering how Paul felt when Lydia responded to the gospel message he shared. Was he worried if he explained the gospel clearly? Did he sit in awe listening to Lydia (and her household) respond to the good news? Did he want to shout in celebration? Before you read her story, pause and pray that God would open your heart to hear from Him today.

> READ ACTS 16:11-14. How is Lydia described economically? How is Lydia described spiritually? Who opened Lydia's heart to hear Paul's message?

On Paul's second missionary journey, he received a vision of a man in the Roman province of Macedonia pleading with him to come and help them. Paul, believing that God was calling them to Macedonia, immediately made plans to travel to the province. Taking Silas and Timothy, Paul made his way to the city of Philippi, a leading city in Macedonia. On the Sabbath day, Paul looked for a place of prayer. Paul had a pattern. When he arrived in a city, he would seek out the Jewish people in the city, typically in a synagogue. Paul would share the gospel with his fellow Jews. Often the Jewish leaders would kick Paul out of their fellowship because they refused to believe Jesus was the Messiah. Then, Paul would seek out the Gentiles of the city.

In Philippi, Paul sought the place where the Jews gathered to pray. Bible scholars believe that Philippi, a Roman colony, did not have a synagogue. A synagogue required the presence of at least ten Jewish men in the city, and at the river, Paul only found a group of women.[1] Luke, the author of Acts, recorded the name of one of the women—Lydia.

NOW READ ACTS 16:15. What stands out to you about the events following Lydia's conversion?

Upon hearing Paul share the gospel, Lydia repented of her sin and trusted Christ as her Savior and Lord. Then, we see Lydia and those in her household, who had also believed the gospel, were baptized. Can you imagine Lydia's joy that day? Immediately, we see that a heart transformed by the gospel leads to actions that reflect the gospel. Lydia extended Christian hospitality (kindness) by inviting Paul, Silas, and Timothy to stay at her house. God specifically sent Paul to Lydia's town so she could hear the gospel. It was not an accident. It was the loving pursuit of a God who sees us and yearns to redeem us.

Skip ahead to the end of the chapter and **READ ACTS 16:40.** This is the only other time Lydia is mentioned in the Bible. What can you add to your understanding of her from this brief scene?

Later in their ministry, Paul and Silas were arrested in the city of Philippi for healing a girl who, plagued by an evil spirit, was misused for profit. Her owners, enraged by their loss of income, dragged Paul and Silas to the authorities, claiming that the two men were creating trouble in the city. Paul and Silas were beaten and thrown in jail. After a miraculous intervention by God, the men were released from prison and returned to Lydia's house where they found encouragement from their fellow brothers and sisters in Christ.

Biblical scholar John Polhill notes that already "the church had grown; Lydia, not surprisingly, made her home available as a house church."[2] Lydia shared freely what she had with her brothers and sisters in Christ. Lydia's actions, even in her home, allowed more and more people to hear the gospel and grow in their faith. It's so easy for us to be self-absorbed and busy, to stop seeing the people around us, to focus less and less on sharing the gospel. It's tempting to forget the transforming power of the gospel and how our actions should reflect its truth.

Paul's visit to Philippi, and Lydia's conversion, started the church in Philippi around AD 50.[3] We don't know if Lydia knew the full legacy she left, but we can see the fruit of her gospel-inspired actions.

READ PHILIPPIANS 1:1-11. (Circle) the words and phrases Paul used to describe the church at Philippi, of which Lydia was a part.

About ten years after Lydia's conversion, Paul wrote a letter to the church in Philippi. The introduction of the letter mentions overseers and deacons, indicating that the congregation had continued to grow and mature. No doubt many things had happened in the years since Paul had last visited, but one thing that hadn't changed was Paul's care for the church. He was grateful for their partnership. He missed them. He prayed for them with joy. He treasured their commitment to the gospel. He prayed for their continued growth in Christ.

While her name is only recorded in two verses of the Bible, Lydia was just as important to God as someone mentioned in one hundred verses.[4] A heart transformed by the gospel led to actions that allowed the church in Philippi to grow. God sought Lydia by calling Paul to Macedonia. It wasn't by accident that Paul found Lydia at the river. It was a God-ordained, holy moment. God also sought you. He called you, redeemed you, and is transforming you into the image of His Son. Like Lydia, you can serve where God has placed you. You have a role in God's mission to seek the lost.

Reflect over the past week. How have your actions reflected the love and grace of your Savior? Where have you fallen short? How or where is God calling you to join Him in His mission to seek the lost?

End today by praying that God would continue to mold your heart and actions to reflect the gospel to those around you.

DAY 02

Priscilla

A PARTNER IN MINISTRY

By Susan Lafferty

Priscilla's story is found in Acts 18. She is best known for being Aquila's wife and a fellow tentmaker with Paul and partnering with him in ministry. Priscilla is also mentioned in Romans 16:3-5; 1 Corinthians 16:19; and 2 Timothy 4:19.

While my husband was training to serve two years in Scotland with the International Mission Board, one question caught his attention and helped him live out his years there with an eye on eternal investment. "Are you going to be permanently temporary? Or temporarily permanent?" As we focus on Priscilla in Scripture today, we'll see that the work of her hands reflected the story of her life. She and her husband were tentmakers. And they moved from place to place. But in the midst of upheaval and transition, Priscilla lived faithfully in the present.

READ ACTS 18:1-23. What do you learn about Priscilla in this passage? List/underline everything you discover.

Priscilla and her husband, Aquila, grew up as members of the Jewish diaspora in the Roman empire, eventually living and working in the city of Rome. The diaspora were Jews scattered outside of Israel at various times in their nation's history. Because of this dispersion, there were communities of Jews all across the empire. Thus, as believers began taking the gospel to the ends of the earth, they often found synagogues and shared the gospel there.

In AD 49, Emperor Claudius had issued an edict, ordering Jews to be expelled from Rome. This was related to Jews disturbing the peace "at the instigation of Chrestus." Most scholars believe "Chrestus" referred to Christos—Jesus Christ.[5] Priscilla and Aquila were forced out of their home and made their way to another city in the empire—Corinth, the provincial capital of Achaia. What appeared to be unsettling upheaval in their lives was used by God to direct their path.

LOOK BACK THROUGH ACTS 18:1-23. List/highlight every description of what Paul was communicating in Corinth. What was he devoted to? What were they hearing in the synagogue and later in the home of Titius Justus? (For further study, read 1 Cor. 2:1-5; 15:1-11 about Paul's proclamation there.)

Paul lived and worked with Priscilla and her husband. They experienced life on life with the great apostle. Most likely, Paul followed his typical pattern of teaching the gospel message in the synagogue (Acts 17:2-3). Thanks in part to Priscilla and Aquila's hospitality in the gospel and with the arrival of Silas and Timothy, Paul was able to stop tentmaking for a time and focus completely on his teaching ministry. The couple played a vital role in the advancement of the gospel in Corinth.

After the events in 18:1-23, Priscilla moved her "tent" again. This time, she and her husband accompanied Paul to Ephesus, where he left them and continued on his journey.

READ ACTS 18:24-28. What was the issue? What role did Priscilla and Aquila play in his life? What do we learn from how they approached Apollos?

These verses tell us about a man named Apollos who showed up in Ephesus eager to tell people about Jesus but who spoke with incomplete knowledge of the gospel. Verse 26 tells us that when Priscilla and Aquila heard what Apollos was teaching, "They took him aside," which literally means "they received him." Perhaps they received him in their home for this time of important explanation. They graciously took the time to teach Apollos a more complete picture of the gospel.

LOOK BACK AT 18:1-23 and remember all that Priscilla observed and learned from Paul. In Ephesus, she and Aquila were able to use what they had learned to help a brother speak the gospel with greater accuracy.

READ ROMANS 16:3-5; 1 CORINTHIANS 16:19; AND 2 TIMOTHY 4:19-22. What added insight do these verses give us into Priscilla's life and her relationship with Paul? What did Paul call her and her husband? What else did he say about them in these passages?

Priscilla devoted her life to Christ in the temporary place. She invested her heart and mind to grow and learn, then instructed others in the truth of the gospel. She opened her home as a place for the body of believers to gather and worship. We live in a temporary world. Perhaps you are on the move or witnessing constant change all around you. How will you follow the example of Priscilla to live faithfully in this moment? With whom will you share what it means to live a life devoted to Jesus? As you wrap up your study today, reflect on the following questions. Prayerfully consider how God has positioned you to join Him in His work during this season of your life.

Today, in what location has God placed you to learn and grow in your understanding of His purpose and plan?

How have others here or elsewhere impacted your life with the gospel? Has someone discipled you in how to walk daily with Christ and grow in understanding His Word? Remember and rejoice in what He has done. Take time to thank those who mentor you through teaching and by example.

Consider all that you have learned through God's Word and the teaching of more mature believers. Is there someone God is calling you to invest in? Your children? A new believer? Your next door neighbor? Ask Him to instruct and lead you in His ways.

Phoebe

A LIFE OF SERVICE

By Amy Whitfield

Phoebe's story is found in Romans 16:1-2. She is best known for carrying Paul's letter to the Romans from Corinth to Rome.

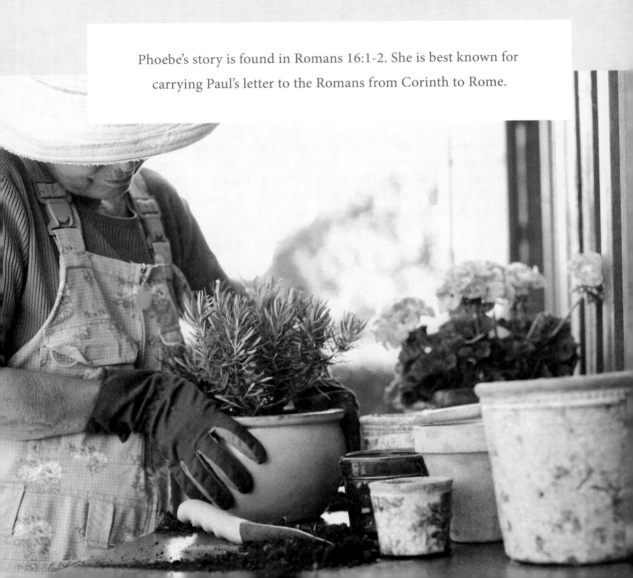

When I was a young adult, a woman in my church named Martha had a reputation among the entire membership. She was known to all, well respected, and honored by everyone from children to church leaders. Her status in the church didn't come from money or power, it came because she was known for her commitment as a true servant.

Martha greeted visitors every week, she participated in Bible studies and supported leaders, and she hosted a monthly breakfast in her home for new members. She was always looking for ways to serve others in the church. Her faith drove her to an attitude of service. I remember being asked to help at one of her new member breakfasts and considered it a great honor to be in her home and a part of her team that day. Her joy in sacrifice was (and still is) infectious and set an example for the church.

When I read the apostle Paul's commendation of Phoebe, a believer he encountered in his journeys, I think of Martha. Martha was clearly a servant in our community, galvanizing others to support the mission of the church. She involved others in her work and gave us a model we could easily follow. Leadership and influence come in many forms, but service is a key component of our work together in the gospel. Supporting the community around us and holding one another up is not about an office of the church or a specific assignment. It is a way of life that we are all called to as brothers and sisters in Christ. This is the example we'll consider as we look at Phoebe's influence today.

READ ROMANS 16:1-2. List everything you learn about Phoebe from these two verses.

What does it mean to "commend" someone (v. 1)?

When Paul left Corinth for Syria with Priscilla and Aquila, the book of Acts tells us that he stopped in Cenchreae. While there, he evidently encountered Phoebe, a well-respected member of the church. She was deeply involved in the mission of the church, so much so that she was part of the delegation that delivered Paul's letter to the church in Rome. In the conclusion of his letter, Paul signaled his trust in Phoebe and told the saints of the Roman church that they should welcome her as one

of their own and help her however she needed. He even went so far as to let them know she had financially supported many, including himself.

Much ink has been spilt over Phoebe's exact role in the church, all hinging on the word that is translated as "servant." It is the same word in the Greek that is translated in other letters of Paul as "deacon."[6] There is debate among scholars as to whether Paul was speaking of Phoebe holding an actual office in the church or simply commending her servanthood. Regardless, Paul's purpose was not to discuss formal roles but rather to introduce her to the Romans and to demonstrate his confidence in her character.

Why is servanthood an important component of leadership, both in official capacities and behind the scenes?

Imagine how Paul might have described you if you were the one delivering the letter to the Romans. What are some words or phrases he could use?

NOW READ MATTHEW 20:20-28. What insight does this scene give you into service in the kingdom of God? What does the request of James and John tell us about our own natural tendencies and desires?

Jesus's disciples were often confused about why He had come. When the brothers James and John came with their mother to express their desire to sit in a place of importance (Mark 10:35-37), He responded by gathering everyone and explaining what it actually meant to follow Him. What He described was not about power and glory. In fact, it was the exact opposite. He told His disciples, "Whoever wants to become great among you must be your servant" (v. 26), using the same Greek word for *servant* that was used later to speak of Phoebe.[7] The message was clear. Greatness only comes through servanthood. Christ didn't come to be served, but to serve.

We are called to do the same with our lives. When Paul wrote to the early church, his encouragement to be servants wasn't just because it was the nice thing to do. The gospel calls us to live a life of service.

What does Jesus's own example teach you about serving God?

We don't know much about Phoebe as a person. We don't know about her family or her upbringing. We don't know if she had a career, although Paul did describe her as a benefactor, which would imply that she had financial means to assist him and others. We don't know how she came to know Christ as her Savior. We don't know what she did specifically in the church at Cenchreae. We do know Paul trusted her with his message to the church in Rome, which tells us that he respected her enough to send her as his representative. He expressed his respect for her by telling the recipients of his letter one thing—this woman's heart was for the church, and they could trust her as well.

It is easy to get swept up in a me-centered culture, to assume that we deserve to have others take care of our needs and that greatness comes from power. But following Christ puts the reverse on display. Just as His sacrifice for our sins is a picture of true humility, greatness in the kingdom of God is humble in spirit and servant-like in action. The gospel frees us to love one another and to give of ourselves to those around us.

How does the description of Phoebe inspire you to serve others? Write down two or three tangible ways that you can carry this out in your own life and church family.

Searching your own heart in full transparency, do you believe that others would describe you in the way that Paul described Phoebe? Take a moment to pray that God would cultivate humility in your heart and make you more like Christ.

DAY 04

Euodia & Syntyche

A PLEA FOR UNITY

By Yvonne Faith Russell

Euodia and Syntyche's story is found in Philippians 4:2-3.
They are known for their interpersonal conflict
and Paul's mediation.

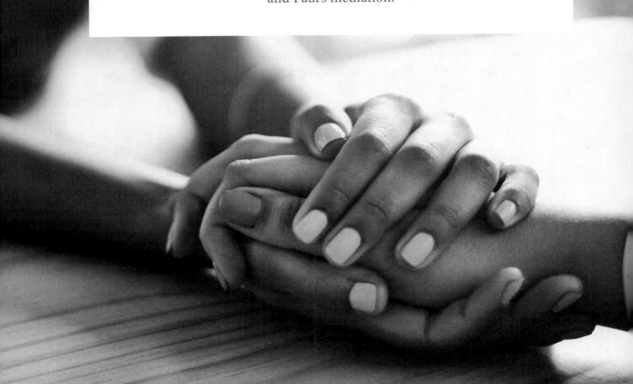

Euodia and Syntyche were two women who helped build and establish the church in Philippi. The Philippian church began with women who gathered for prayer outside the city near a riverbank because the Jewish community in the region was too small to have a synagogue, the official place of Jewish worship (Acts 16).[8] It's possible Euodia and Syntyche, the women we'll learn about today from Paul's letter to the Philippian church, were among some of these women who gathered during these prayer meetings.

READ PHILIPPIANS 4:1-3. What do you learn about Euodia and Syntyche from these brief verses?

It's no accident that Euodia and Syntyche were living in the region of Philippi when Paul visited. Unlike other regions at that time in history, women had a great measure of freedom in Philippi.[9] Like men, they were allowed to meet publicly, own businesses, and amass wealth. And God, being the master orchestrator of events, used that cultural freedom for His glory. Paul described these two women as "contending" or "laboring" at his side for the gospel. Through allowing Euodia and Syntyche to partner with Paul in sharing the gospel, God showed us His divine intentionality and ability to use our freedoms to advance His kingdom. Evidently though, the women found themselves in a disagreement or conflict that Paul had caught wind of.

LOOK AGAIN AT PHILIPPIANS 4:1. What was Paul's relationship like with the men and women at the church in Philippi?

Think back over the women you've studied. Who else was a part of the church at Philippi? (Hint: Read Acts 16:11-15 if you need a reminder.)

Paul spent a good bit of time in Philippi during his missionary journey, and it's obvious from Philippians 4:1 that the people there meant a great deal to him. Several years after the church in Philippi was initially established and Paul spent time there with Lydia and others, Paul wrote a letter to the church in Philippi—what we now know as the book of Philippians. In Philippians 4:2-3, Paul urged Euodia and Syntyche to set aside their disagreement and be united in Christ. We don't know what their dispute was about but given that Paul mentioned it publicly in his letter to the church, it's evident that it was affecting the congregation. How did these women go from laboring side by side with Paul in sharing the gospel to disagreeing so sharply that Paul openly addressed their dispute in his letter to the church?

> Why is conflict dangerous to Christian fellowship and church community? Think about the effects it has on the individuals involved, the church body as a whole, and the witness to those outside of the church.

Euodia and Syntyche remind us that even though we have accepted Christ into our lives, we will still have conflict with other people. The important part is how we work through that conflict so that we aren't magnifying ourselves in our dispute but glorifying God in our unity. Paul spent much of chapters 1 and 2 of Philippians stressing heavily the church's unity in Christ. This public dispute was an affront to the unity that Jesus, and therefore Paul, expects from His church.

> READ PHILIPPIANS 4:4-6. Below is a list of all the commands Paul included in these verses. Next to each one, note how that instruction promotes unity instead of discord.

> Rejoice in the Lord always (v. 4).

> Let your graciousness be known to everyone (v. 5).

Don't worry about anything (v. 6).

Present your requests to God (v. 6).

NOW READ PHILIPPIANS 4:7. Ultimately, what is the only way we are able to live in unity with others?

When Jesus transforms our lives, the ability to be unified among our differences is a byproduct. Jesus transforms our sin nature and helps us submit ourselves to His direction and leadership. When ordinarily we may be tempted to fight until we win, we can gently submit our wills to the King and allow Him to work in our hearts. Philippians 4:5 reminds believers to let their gentleness be evident to everyone. Transformed believers can replace feuding with graciousness and work to reconcile their differences.

LOOK BACK AT PHILIPPIANS 4:3. Paul's words weren't only constructive for these two women, he also praised them because they "contended for the gospel at my side" and their "names are in the book of life." What do you take away from these two descriptive statements?

Even as Paul challenged Euodia and Syntyche to pursue unity, he also praised them for contending for the gospel. He highlighted their error of discord, but also noted their sincerity of gospel witness. It's within this context of knowing all they are capable of when they work together for the gospel that he pleaded for them to remember the unity they already have experienced.

As you studied Euodia and Syntyche today, did you sense conviction about a relational discord in your own life? Use Paul's instructions in Philippians 4:4-6 to prayerfully seek reconciliation and unity in that relationship.

Lois & Eunice

A LEGACY OF DEVOTION

By Tina Boesch

Lois's story is found in 2 Timothy 1:5. She is known for being Timothy's grandmother and an example of faith.

Eunice's story is also found in 2 Timothy 1:5. She is best known for being Timothy's mother and an example of faith. Eunice is also mentioned in Acts 16:1.

My daughter's name is Lois. She was named to honor her paternal grandmother, a woman who seemed to possess her own electromagnetic force. Grandma Lois drew the family together. Her home was always the natural meeting point where we gathered with cousins, aunts, and uncles anytime we were in Louisiana. Something with crawfish was usually on the menu. There was always dessert, and there was always laughter.

Orphaned at a young age, Grandma Lois survived a lonely childhood with relatives who struggled to feed the kids under their care. By her accounts there was a stretch of years when she subsisted mostly on sweet potatoes, a vegetable she declined to eat afterward. Despite her painful past, Lois was full of good humor and loved to tease her grandchildren mercilessly. More importantly, she was marked by committed faith that was passed on to her husband, her son, and then her grandsons. A faith now evidenced in many of her great grandchildren. I can't help but see parallels between Grandma Lois and the Lois we read about in 2 Timothy.

READ 2 TIMOTHY 1:1-7. What does Paul recall about Lois and Eunice?

Write the word Paul uses to describe their faith in verse 5.

In Greek the word used to describe Lois and Eunice's faith is *anypokritos*, a word that sounds a lot like *hypocrite*.[10] But the "an" in the front negates the word, so *anypokritos* literally means that Lois and Eunice's faith was "not hypocritical." These two women were known for a faith that was genuine, true, authentic. Most English translations use the word *sincere* to describe their devotion to the Lord.

Write your own definition of *sincere*, then compare it with a dictionary definition.

Can you think of someone in your life whose faith you would describe as sincere? What were evidences of that person's sincere faith?

Look again at verse 5 written below and (circle) the verb in the sentence:

> . . . your sincere faith that first lived in your grandmother Lois and in your mother Eunice . . .

Faith is not just the affirmation of a set of beliefs; it's something that lives in us. When faith in Jesus Christ takes up residence in our souls, it transforms every part of our being, every aspect of our lives. And faith that is living is not static. Like all living things, it grows and matures over time. Like a tree planted by streams of water, it bears fruit in our lives and in the lives of others.

LOOK BACK AT 2 TIMOTHY 1:5 and notice the progression. Who did Paul say first believed in the family?

That's right—Timothy's grandmother Lois. In this verse we get a sense that Lois was faithful in passing on her devotion to the Lord to Eunice. And that both women shared the faith that lived in them with Timothy. A living faith is not a private faith. Our belief in Christ is too precious to hide; it isn't something to keep to ourselves. And that's especially true as we relate to those within our own families, most notably those who are young, impressionable, and trying to make sense of the world.

You may not have benefitted from growing up with a grandmother or mother who cultivated faith in you. But you can become the sort of woman who nurtures faith in others. Our children, nieces, nephews, friends, students, and the children in our churches need to see the sincere faith that lives in us. They need to hear us talk about what we're learning from the Lord, how Scripture is challenging us and changing us, and how the Holy Spirit is working in us to conform us to the image of Christ.

Paul didn't tell us much about Lois and Eunice, but we can glean a little bit more from one other passing reference to Eunice in Acts 16.

READ ACTS 16:1. How is Eunice described in this verse?

Lois and Eunice were Jewish women who believed that Jesus was the fulfillment of God's promises to their ancestors Abraham and Sarah. In Genesis 18:19 we read that God said, "I have chosen [Abraham] so that he will command his children and his house after him to keep the way of the LORD by doing what is right and just." From the very beginning of God's relationship with the people He called to follow Him, He expressed the expectation that parents in the faith would teach the ways of the Lord to their children and grandchildren. As women devoted to the Lord, we bear a responsibility to encourage the generations that come after us in the same way. Our lives should reflect the values of the kingdom Jesus came to establish and display the fruit of God's Spirit living in us.

In Paul's first letter to Timothy, he encourages this young man to a life of devotion. As we wrap up today's study, let's look at Paul's inspiring challenge because it applies equally to women whose lives are committed to the Lord.

READ 1 TIMOTHY 6:11-16. What did Paul say to pursue in verse 11?

What did he say to hold on to in verse 12?

Who brings about this good work in us (v. 15)?

Friend, God is at work in you. I hope through this study you've been encouraged by the truth that your devotion isn't a result of your effort, hard work, or striving; rather, it's a testimony to God's grace in your life. And just as Lois and Eunice's lives drew Timothy into a relationship with God, this grace dwells in you so that you can share it with others.

Take a moment to pray. Ask the Lord to help you pursue righteousness, faith, love, endurance, and gentleness. As you close your time of prayer read 1 Timothy 6:15-16 aloud as a confession of your faith and devotion. May we take hold of eternal life and share that life with others. To God be the glory.

God will bring this about in his own time. He is the blessed and only Sovereign, the King of kings, and the Lord of lords, who alone is immortal and who lives in unapproachable light, whom no one has seen or can see, to him be honor and eternal power. Amen.

1 TIMOTHY 6:15-16

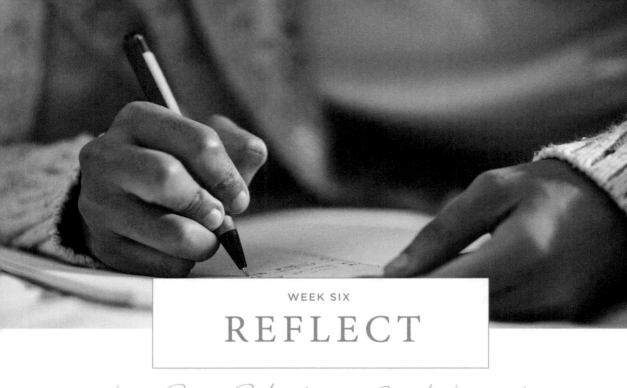

REFLECT

Lydia, Priscilla, Phoebe, Euodia & Syntyche, Lois & Eunice

Take a few minutes to reflect on the truths you uncovered in your study of God's Word this week.
Journal any final thoughts below, or use the space to take notes during your Bible study group conversation.
The three questions on the opposite page can be used for your personal reflection or group discussion.

Download the *Devoted* leader guide at lifeway.com/devoted

As you reflect on the Bible passages you read this week,
what stands out to you about the character of God?

How have you been challenged and encouraged in your relationship
with Jesus through the Scripture you studied?

Write down one way you can use what you've
learned this week to encourage someone else.

BECOMING A CHRISTIAN

Romans 10:17 says, "So faith comes from what is heard, and what is heard comes through the message about Christ."

Maybe you've stumbled across new information in this study. Or maybe you've attended church all your life, but something you read here struck you differently than it ever has before. If you have never accepted Christ but would like to, read on to discover how you can become a Christian.

Your heart tends to run from God and rebel against Him. The Bible calls this sin. Romans 3:23 says, "For all have sinned and fall short of the glory of God."

Yet God loves you and wants to save you from sin, to offer you a new life of hope. John 10:10b says, "I have come so that they may have life and have it in abundance."

To give you this gift of salvation, God made a way through His Son, Jesus Christ. Romans 5:8 says, "But God proves his own love for us in that while we were still sinners, Christ died for us."

You receive this gift by faith alone. Ephesians 2:8-9 says, "For you are saved by grace through faith, and this not from yourselves; it is God's gift—not from works, so that no one can boast."

Faith is a decision of your heart demonstrated by the actions of your life. Romans 10:9 says, "If you confess with your mouth, 'Jesus is Lord,' and believe in your heart that God raised him from the dead, you will be saved."

If you trust that Jesus died for your sins and want to receive new life through Him, pray a prayer similar to the following to express your repentance and faith in Him:

Dear God, I know I am a sinner. I believe Jesus died to forgive me of my sins. I accept Your offer of eternal life. Thank You for forgiving me of all my sins. Thank You for my new life. From this day forward, I will choose to follow You.

If you have trusted Jesus for salvation, please share your decision with your group leader or another Christian friend. If you are not already attending church, find one in which you can worship and grow in your faith. Following Christ's example, ask to be baptized as a public expression of your faith.

WE ARE LIFEWAY WOMEN.

We are daughters, first and foremost—children of the King.

We bear the image of our Father.

We are sisters, too, part of the family of God. The bride of Christ.

We study the Bible—the inspired Word of God—faithfully.

We believe God's Word is profitable for teaching and training in righteousness.

We believe it is living and active.

We pray alone and in community, believing God hears and cares for His children.

We laugh, grow, and worship alongside our fellow image bearers.

We make disciples and teach them to observe the commands of Christ.

We have been called out of the darkness and into His marvelous light.

God has placed us here for such a time as this.

We are known. We are free. We are loved.

We are Lifeway Women.

Discover the very best Bible studies Lifeway Women has to offer

to get—and stay—in God's Word.

lifeway.com/women

CONTRIBUTORS

KRISTEL ACEVEDO

Kristel Acevedo is the spiritual formation director at Transformation Church, where she oversees the discipleship pathways for the congregation. She is also a writer and Bible teacher and is currently pursuing a Doctor of Ministry at the Wheaton College Graduate School. She lives in South Carolina with her husband and two kids.

TINA BOESCH

Tina Boesch serves as manager of the Lifeway Women Bible Studies team. She earned a Master of Arts in Theology at Regent College in Vancouver, British Columbia. For fourteen years, she and her husband and their three kids called Istanbul, Turkey, home. Now they've settled north of Nashville, but she still misses steaming cups of Turkish tea. Tina is the author of *Given: The Forgotten Meaning and Practice of Blessing*.

W. DIANE BRADEN

W. Diane Braden considers writing to be a beautiful gift from God and her passion. She majored in journalism at Tennessee State University and has worked for Lifeway for more than twenty years. She is married to the love of her life, Ronald, with whom she cofounded Holy Reconciliation Ministries.

NANCY COMEAUX

Nancy Comeaux is production editor for Lifeway magazines and devotionals. She has worked at Lifeway for more than forty years. Nancy is married to Marc, and they are parents of two young adult children, Meagan and Colton. She leads the drama ministry at her church in Joelton, Tennessee.

YANA JENAY CONNER

Yana Jenay Conner is a writer and Bible teacher who seeks to help others exchange a secular worldview for a biblical one. By God's grace, she earned a Master in Divinity in Christian Ministry from Southeastern Baptist Theological Seminary and has served in full-time ministry for the past sixteen years. Yana currently serves at Vertical Church as the discipleship director and hosts a podcast, *Living Single with Yana Jenay*.

CONTRIBUTORS

EMILY DEAN

Emily Dean serves as assistant professor of Ministry to Women at New Orleans Baptist Theological Seminary and Leavell College. She and her husband, Dr. Jody Dean, along with their two children, live in the New Orleans area. You can follow her on social @emily.w.dean (Instagram) or @emilywdean (Twitter).

DEBBIE DICKERSON

Debbie Dickerson and her husband, Steve, love spending time with their oldest son, Landon, and his wife, Alyssa, and their college-aged son, Kaden. Debbie enjoys serving as editor of *Mature Living* and as a children's teacher at ClearView Baptist Church in Franklin, Tennessee.

ERIN FRANKLIN

Erin Franklin is a production editor on the Lifeway Women Bible Studies team. A graduate of Lipscomb University, she enjoys a good ping-pong match, photography, and learning new things. You can connect with her on Instagram @erin_franklin and on Twitter @erinefranklin.

DONNA GAINES

Donna Gaines is the wife of Dr. Steve Gaines, pastor of Bellevue Baptist Church; the mother of four; and "Nonna" to sixteen. She is a Bible teacher, missions advocate, author, editor of *A Daily Women's Devotional*, and involved with Bellevue Women. Donna is the founder and President of the Board of the Pastor's Wives' Session of the SBC and the founder and President of ARISE2Read.

ASHLEY MARIVITTORI GORMAN

Ashley Marivittori Gorman serves as an associate publisher at B&H Publishing Group. She holds a Master of Divinity from Southeastern Theological Seminary and has been trained under The Charles Simeon Trust. Ashley and her family live in Nashville, Tennessee. You can find her writing in various Lifeway Women Bible studies, books like *World on Fire*, and on digital venues like *The Gospel Coalition*, *Lifeway Voices*, *ERLC*, and *Christ and Culture*.

CONTRIBUTORS

SHELLY D. HARRIS

Shelly D. Harris is a content editor for Lifeway Kids. She is a graduate of Murray State University and the Southern Baptist Theological Seminary. As a former kids' minister, Shelly is passionate about equipping the church to share the gospel and disciple kids. She currently serves as a kids ministry coordinator at The Church at Station Hill in Spring Hill, Tennessee.

MICHELLE R. HICKS

Michelle R. Hicks is the managing editor for *Journey* devotional magazine and serves on the leadership training team with Lifeway Women. Her prayer is for women to grow closer to Jesus every day through His Word.

JULIA B. HIGGINS

Julia B. Higgins serves as assistant professor of Ministry to Women and associate dean of Graduate Program Administration at Southeastern Baptist Theological Seminary. She is the author of *Empowered and Equipped* and coediter of *The Whole Woman*. She is married to Tony, and they reside in the Raleigh-Durham area.

SARAH HUMPHREY

Sarah Humphrey is a wife and homeschool mom to three kids while also working as an artist, author, and voice actor. Her writing can be found in her devotional, *40 Days to a Joyful Motherhood*, and her voice in several commercials, children's books, and audiobooks. You'll most often find her chasing her kids around the neighborhood. Her latest book for tweens, *Solomon Says Devotional*, released in 2021.

ELIZABETH HYNDMAN

Elizabeth Hyndman is the editorial project leader for Lifeway Women Academy and cohosts the *MARKED* podcast. A Nashville native, grammarian, and tea drinker, Elizabeth can be found on Instagram and Twitter @edhyndman.

CONTRIBUTORS

KRISTIN L. KELLEN

Dr. Kristin Kellen is an associate professor of Biblical Counseling and the associate director of EdD Studies at Southeastern Baptist Theological Seminary. Her focus is counseling children, teens, and their families. She is married to her husband, Josh, and they have four sweet little ones. Kristin is the coauthor of *The Gospel for Disordered Lives*, *The Whole Woman*, and *Counseling Women*.

KELLY D. KING

Kelly D. King is the manager of Magazines/Devotional Publishing and Women's Ministry Training for Lifeway Christian Resources. She has a Master of Theological Studies degree from Gateway Seminary and is currently pursuing her Doctor of Ministry degree. She is a contributor to the Lifeway Women's Bible and several Lifeway Women studies. Her favorite title is KK to her grandson, Luken.

SUSAN LAFFERTY

Susan Lafferty and her husband, Todd, have served with the International Mission Board for more than thirty years, mainly in South and Southeast Asia. They are the parents of three young adults. Susan writes weekly at susanlafferty.com.

RAVIN MCKELVY

Ravin McKelvy is a copywriter at Lifeway and graduated with a degree in communications from Moody Bible Institute. She is passionate about the intersection of art and theology and sharing the daily realities of Christian living on social media.

AMANDA MEJIAS

Amanda Mejias is the Lifeway Girls Brand Specialist, which is just a super fun way of saying that she serves parents and leaders of teen girls. After serving on church staff for many years, she is passionate about building relationships and creating resources that equip the local church. Amanda is wife to her wonderful husband, Brandon, and lives out her dream of being a working mom.

CONTRIBUTORS

TESSA MORRELL

Tessa Morrell is a production editor for Lifeway Women. She is passionate about serving in her church and studying Scripture with others. She also enjoys visiting local coffee shops, browsing antique stores for hours, and creating art of all kinds.

JACLYN S. PARRISH

Jaclyn S. Parrish is the director of marketing at Southwestern Seminary. She holds a Bachelor of Arts in English and Christian Studies from Dallas Baptist University and a Master of Arts in Religion from the B.H. Carroll Theological Institute. She has served in local churches and Southern Baptist entities for more than a decade and has written for *The Gospel Coalition*, *Christianity Today*, and *Love Thy Nerd*.

YVONNE FAITH RUSSELL

Yvonne Faith Russell is a passionate writer, editor, dancer, teacher, and choreographer. A Nashville native, she manages two careers in publishing and performing arts. She is the author of *A Word to the Wise: Lessons I Learned at 22* and *Mature & Complete: A Devotional Journal for Healing, Value, and Satisfaction in Christ*.

RACHEL MATHEIS SHAVER

Rachel Matheis Shaver works with all the books at Lifeway by day and spends the rest of her time wrangling her kids whom she affectionately calls, "the mafia."

TERRI STOVALL

Terri Stovall is the dean of women and professor of Women's Ministry at Southwestern Baptist Theological Seminary, where she oversees the Southwestern Women's Center and the Women's Leadership Institute. Terri is the coauthor of *Women Leading Women: The Biblical Model for the Church* and is a contributing author of *The Teaching Ministry of the Church*, *The Christian Homemaker's Handbook*, and *The Devotional for Women* series. She and her husband, Jay, currently live in Arlington, Texas.

CONTRIBUTORS

CHRISTINE THORNTON

Christine Thornton desires to help the church mature as Christians grow in clarity of the gospel and the ability to effectively communicate it to one another and the world. She currently serves as assistant professor of Christian Thought and director of the Master of Theology program at Southeastern Baptist Theological Seminary. She has contributed to *The Gospel Coalition*, *Christianity Today*, and numerous other publications.

LAYNIE TRAVIS

Laynie Travis is in love with Jesus, her husband, her children, and spreading the good news of the gospel. In the midst of raising a large family, Laynie felt the Lord nudge her to put her faith into action and start a Bible study in her local community. That one faith step inspired her to teach, write Bible studies and books, start a podcast, lead women's conferences, and start Take Heart Ministries. Connect with Laynie on Instagram @takeheartministries and @laynietravis, or on Facebook @takeheartministries.

AMY WHITFIELD

Amy Whitfield is executive director of communications at The Summit Church in Raleigh-Durham. She is coauthor of the book *SBC FAQs: A Ready Reference* and is cohost of the podcast *SBC This Week*. She has also contributed to multi-author volumes including *Ministering to the Whole Woman* and *Praying at the Crossroads*. In 2019, she helped launch the SBC Women's Leadership Network. Amy and her husband, Keith, have two children and live in Wake Forest, North Carolina.

MARY C. WILEY

Mary Wiley is the author of *Everyday Theology*, an eight-week Bible study exploring essential doctrines and why they matter in our everyday lives. She holds a Bachelor of Arts in Christian Studies and a Master of Arts in Theological Studies from The Southern Baptist Theological Seminary. She and her husband, John, have three children and live in the Nashville area.

CHRISTINA ZIMMERMAN

Christina is the content editor for the *YOU* Bible Study at Lifeway Christian Resources. She serves in ministry with her husband, Harry Zimmerman Jr., at Faith United Baptist Church, Nashville. They have five children.

ENDNOTES

WEEK ONE

1. Carolyn Custis James, *Lost Women of the Bible* (Grand Rapids: Zondervan, 2005), 35–36.

2. Thomas L. Constable, "Notes on Genesis," Soniclight.com, accessed February 8, 2023, https://www.planobiblechapel.org/tcon/notes/html/ot/genesis/genesis.htm.

3. K. A. Mathews, *Genesis 11:27–50:26, vol. 1B, The New American Commentary* (Nashville: Broadman & Holman Publishers, 2005), 184.

4. James Montgomery Boice, *Genesis: An Expositional Commentary* (Grand Rapids: Baker Books, 1998), 571.

5. Victor Harold Matthews, Mark W. Chavalas, and John H. Walton, *The IVP Bible Background Commentary: Old Testament, electronic ed.* (Downers Grove: InterVarsity Press, 2000), Ge 14:14–16.

6. T. Desmond Alexander, Genesis Notes, *The ESV Study Bible* (Wheaton: Crossway, 2008), 78.

7. M. G. Easton, *Illustrated Bible Dictionary and Treasury of Biblical History, Biography, Geography, Doctrine, and Literature* (New York: Harper & Brothers, 1893), 304.

WEEK TWO

1. K. A. Mathews, *Genesis 11:27–50:26, vol. 1B, The New American Commentary* (Nashville: Broadman & Holman Publishers, 2005), 705–709.

2. Timothy R. Ashley, *The Books of Numbers (New International Commentary on the Old Testament)* (Grand Rapids: William B. Eerdmans Publishing Company) Kindle Edition, 227.

3. Gordon J. Wenham, *Numbers: An Introduction and Commentary, vol. 4, Tyndale Old Testament Commentaries* (Downers Grove, IL: InterVarsity Press, 1981), 128.

4. Michael Wilcock, *The Message of Judges* (Nottingham: Inter-Varsity Press, 1992), 62-64.

WEEK THREE

1. Sâkal: Strongs H7919, Blue Letter Bible, accessed February 8, 2023, https://www.blueletterbible.org/lexicon/h7919/csb/wlc/0-1/.

2. Robert D. Bergen, *1, 2 Samuel, vol. 7, The New American Commentary* (Nashville: Broadman & Holman Publishers, 1996), 250.

3. Rachel Friedlander, "Five Things About Esther That Nobody Talks About," *Inherit*, accessed February 8, 2023, https://jewsforjesus.org/publications/inherit/five-things-about-esther-that-nobody-talks-about.

4. Ibid.

5. Ibid.

WEEK FOUR

1. Robert H. Stein, *The New American Commentary, Luke, Volume 24* (Nashville: Broadman & Holman Publishers, 1992).

2. Trent C. Butler, *Luke, vol. 3, Holman New Testament Commentary* (Nashville: Broadman & Holman Publishers, 2000), 7.

3. Alistair Begg, "Elizabeth and Zechariah," *Truth For Life*, December 7, 2014, https://www.truthforlife.org/resources/sermon/elizabeth-and-zechariah/.

4. Robert H. Stein, *Luke, vol. 24, The New American Commentary* (Nashville: Broadman & Holman Publishers, 1992), 74.

5. Trent C. Butler, *Luke, vol. 3, Holman New Testament Commentary* (Nashville: Broadman & Holman Publishers, 2000), 8.

6. Robert H. Stein, *Luke, vol. 24, The New American Commentary* (Nashville: Broadman & Holman Publishers, 1992), 75.

7. Kenneth W. Osbeck, *101 More Hymn Stories* (Grand Rapids: Kregel Publications, 1985), 287–288.

8. Louisa M. R. Stead, "'Tis So Sweet to Trust in Jesus," 1882, Public Domain.

9. Kenneth W. Osbeck, *101 More Hymn Stories* (Grand Rapids: Kregel Publications, 1985), 287–288.

10. "Herod's Temple Complex in the Time of Jesus," *The ESV Study Bible* (Wheaton: Crossway, 2008), 1950–1951.

11. Robert H. Stein, *The New American Commentary: An Exegetical and Theological Exposition of Holy Scripture, Luke, Vol. 24* (Nashville: Broadman & Holman Publishers, 1992), 36–37, 117–118.

12. "Herod's Temple Complex in the Time of Jesus," *The ESV Study Bible* (Wheaton: Crossway, 2008), 1950–1951.

13. Stephanie Catmull, "Joanna," *Women in the Bible*, accessed May 3, 2022, https://womeninscripture.com/joanna/.

14. William Barclay, ed., *The Gospel of Luke, The Daily Study Bible Series* (Philadelphia: The Westminster John Knox Press, 1975), 96.

15. David Guzik, "Study Guide for Luke 8," Blue Letter Bible, accessed May 3, 2022, https://www.blueletterbible.org/Comm/archives/guzik_david/StudyGuide_Luk/Luk_8.cfm.

16. Elizabeth Fletcher, "Joanna, Jesus' Disciple," Women in the Bible, accessed May 3, 2022, http://womeninthebible.net/women-bible-old-new-testaments/Joanna/.

17. Lisa Leonce, "Joanna – A Leader Who Refused to Be Defined by Her Past," Kyria, accessed May 3, 2022, https://kyrianetwork.com/joanna-a-leader-who-refused-to-be-defined-by-her-past/.

WEEK FIVE

1. Herbert Lockyer, *All the Women of the Bible* (Grand Rapids: Zondervan, 1967).

2. Ann Spangler and Lois Tverberg, *Sitting at the Feet of Rabbi Jesus* (Grand Rapids: Zondervan, 2009), 14.

3. Matthew Henry and Thomas Scott, *Matthew Henry's Concise Commentary* (Oak Harbor: Logos Research Systems, 1997), Jn 11:17.

4. Wayne Grudem and Thomas R. Schreiner, Luke Notes, *The ESV Study Bible* (Wheaton: Crossway, 2008), 1967.

5. Akoloutheó: Strongs NT 190, Bible Hub, accessed February 8, 2023, https://biblehub.com/greek/190.htm.

6. Note: various translations of Matthew 27:55; Mark 15:41; and Luke 8:3 say "ministered," "helped," "provided," etc.

7. Thomas L. Constable, "Notes on Acts," Soniclight.com, accessed February 8, 2023, https://www.planobiblechapel.org/tcon/notes/html/nt/acts/acts.htm.

WEEK SIX

1. F. F. Bruce, *The Book of the Acts, The New International Commentary on the New Testament* (Grand Rapids: Wm. B. Eerdmans Publishing Co., 1988), 310.

2. John B. Polhill, *Acts, vol. 26, The New American Commentary* (Nashville: Broadman & Holman Publishers, 1992), 357–358.

3. Eckhard J. Schnabel, *Acts* (Grand Rapids: Zondervan, 2012), 756.

4. "Who was Lydia in the Bible?", GotQuestions.org, accessed February 8, 2023, https://www.gotquestions.org/Lydia-in-the-Bible.html.

5. Eckhard J. Schnabel, *Acts, Expanded Digital Edition, Zondervan Exegetical Commentary on the New Testament* (Grand Rapids: Zondervan, 2012), Ac 17:6–7.

6. Everett F. Harrison and Donald A. Hagner, "Romans," *The Expositor's Bible Commentary: Romans–Galatians (Revised Edition), vol. 11* (Grand Rapids, MI: Zondervan, 2008), 226.

7. Diakonos: Strong's G1249, Blue Letter Bible, accessed February 8, 2023, https://www.blueletterbible.org/lexicon/g1249/kjv/tr/0-1/.

8. "Philippi," *NLT Illustrated Study Bible* (Carol Stream: Tyndale House Publishers, 2015), 2173.

9. "Philippians" *NKJV Woman's Study Bible*, (Nashville: Thomas Nelson, Inc., 2016).

10. Anypokritos: Strongs G505, Blue Letter Bible, accessed February 8, 2023, https://www.blueletterbible.org/lexicon/g505/csb/mgnt/0-1/.

Looking for your next study?

CHECK OUT THIS ONE ON FOSTERING A GRATEFUL HEART.

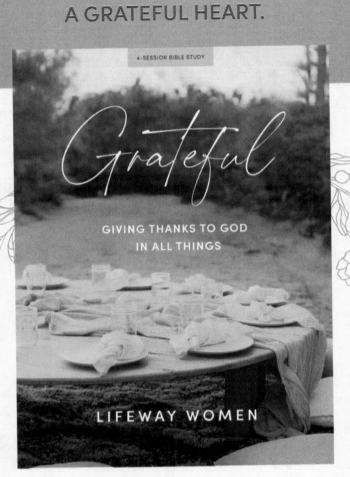

Gratitude brings such blessing and joy to our lives and to those around us. When we are a thankful people, we point to our good God who loves and provides for us. But how can we develop hearts overflowing with thanksgiving?

In this 4-session study, discover biblical characters who demonstrated grateful hearts. Each week you'll immerse yourself in the Bible's teaching on gratitude and be challenged to practice being grateful. When you understand and embrace the biblical foundation for living with a grateful heart, you're better able to thank God in all things.

Bible Study Book **005841132** $16.99

lifeway.com/grateful